Masterpieces
of the J. Paul Getty Museum

DRAWINGS

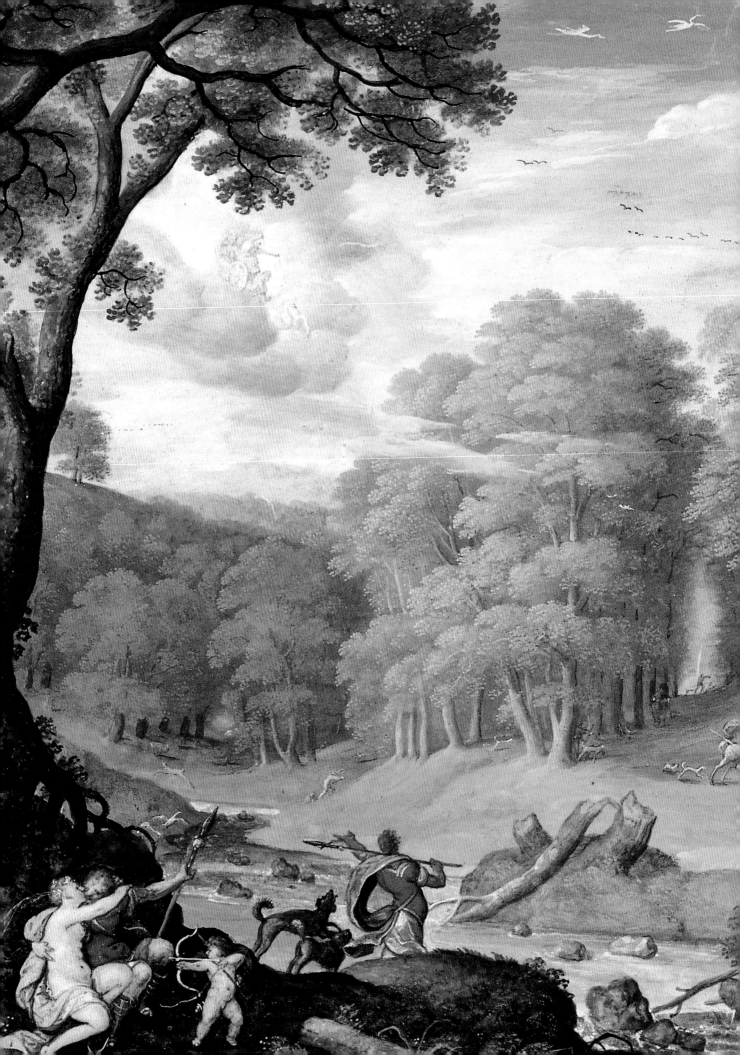

Masterpieces
of the J. Paul Getty Museum

DRAWINGS

Los Angeles
THE J. PAUL GETTY MUSEUM

Frontispiece:
HANS BOL
Flemish, 1534–1593
Landscape with the Story of
Venus and Adonis [detail]
Bodycolor heightened with
gold on vellum
92.GG.28 (See no. 56)

At the J. Paul Getty Museum:

Christopher Hudson, *Publisher*
Mark Greenberg, *Managing Editor*
Benedicte Gilman, *Editor*
Suzanne Watson Petralli, *Production Coordinator*
Charles Passela, *Photographer*

Text for the Italian, French, Spanish, and British schools
prepared by Nicholas Turner; text for the German and Swiss
and for the Dutch and Flemish schools prepared by Lee Hendrix

Designed and produced by Thames and Hudson
and copublished with the J. Paul Getty Museum

Library of Congress Card Number 96-23151

ISBN 0-89236-438-6

Color reproductions by CLG Fotolito, Verona, Italy

Printed and bound in Singapore by C.S. Graphics

CONTENTS

DIRECTOR'S FOREWORD

This book offers a sampling of the Getty Museum's five hundred-odd drawings, every one of which has been bought within the past fifteen years. Such a rapid growth deserves explanation.

J. Paul Getty died in 1976, leaving to his museum an unexpected legacy worth seven hundred million dollars. Getty's art collection—which was installed in his house in Malibu and opened to the public in 1954, then moved twenty years later to the reconstructed Roman villa he had built for the purpose—was an expression of his personal taste and always narrow in scope: there were Classical antiquities, French furniture and decorative arts, and European paintings. There were no drawings. In 1981 it was evident to the trustees (who were also envisioning new programs for scholarship, conservation, and education that would be undertaken by the Getty Trust) that the Museum's collections could not only be strengthened but also diversified. When the well-known Rembrandt chalk drawing *Nude Woman with a Snake* (no. 62) appeared at auction, George Goldner, an art historian and drawings collector who was serving as head of the Museum's photo archive, persuaded the Board that they should buy it. They did, and subsequently took his recommendations for several dozen more purchases. When I arrived in 1983, we established a curatorship and a Department of Drawings, and George Goldner spent a decade building the collection energetically and shrewdly. He has been succeeded by Nicholas Turner, whose purchases since 1993 have added to the strength of the collection and altered its shape.

Drawings were a natural choice for the Getty Museum. They have a logical relation with our paintings and sculpture, and since many excellent drawings still remained in private hands, we had a chance of creating a distinguished group. Since drawings are the most direct works of art, they have an unusual appeal to museum visitors. Their spontaneity helps make them accessible, and so does the fact that most of us have struggled with drawing ourselves.

The aim of the collection is to represent the different schools of European drawing until 1900 with examples of the first quality. In 1981 few would have thought it possible to succeed so well. Sales from English country houses such as Chatsworth (in 1984 and 1987) and Holkham (in 1991) were a boon. In general, however, the market has been increasingly impoverished, and the brilliant rarities of the 1980s seldom appear. Since fewer fine older drawings are available nowadays, the focus of the collection has shifted somewhat, toward eighteenth- and nineteenth-century examples.

The collection is being published in a series of catalogues: Volume 1, by George R. Goldner, with the assistance of Lee Hendrix and Gloria Williams, in 1988; Volume 2, by George R. Goldner and Lee Hendrix with the assistance of Kelly Pask, in 1992;

Volume 3, by Nicholas Turner, Lee Hendrix, and Carol Plazzotta, in 1997. Volume 4 is in preparation.

The text of this book was written by Nicholas Turner and Lee Hendrix, who have my warm thanks.

As I write, a gallery for regular exhibitions of drawings from the collection is being finished at the new Getty Museum at the Getty Center in west Los Angeles, which is to open at the end of 1997. Plans are being made for loan exhibitions of drawings as well. We hope above all that readers who make discoveries in this book will come to see the drawings themselves.

<div align="right">

JOHN WALSH
Director

</div>

NOTE TO THE READER

In the dimensions height precedes width; diameter is abbreviated Diam.

List of abbreviated catalogue references:

Cat. I = George R. Goldner et al. *European Drawings*, vol. 1. *Catalogue of the Collections.* Malibu, The J. Paul Getty Museum, 1988.

Cat. II = George R. Goldner and Lee Hendrix. *European Drawings*, vol. 2. *Catalogue of the Collections.* Malibu, The J. Paul Getty Museum, 1992.

Cat. III = Nicholas Turner, Lee Hendrix, and Carol Plazzotta. *European Drawings*, vol. 3. *Catalogue of the Collections.* Los Angeles, The J. Paul Getty Museum, 1997.

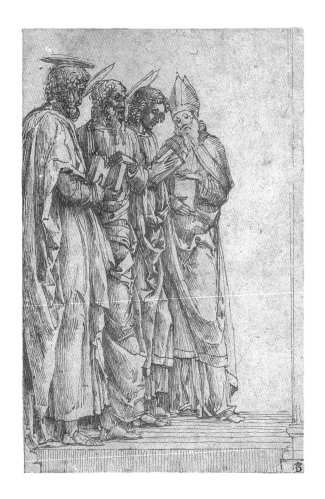

1 ANDREA MANTEGNA
Italian, circa 1431–1506
*Study of Four Saints: Peter,
Paul, John the Evangelist,
and Zeno*

Pen and brown ink, traces of red
chalk on book held by Saint Zeno
19.5 x 13.1 cm (7¹¹/₁₆ x 5³/₁₆ in.)
Cat. I, no. 22; 84.GG.91

The four saints occur in the left-hand wing of the triptych of the *Virgin and Child
with Saints,* known as "The Altarpiece of San Zeno," painted by Mantegna in
1456–59 for the high altar of the Church of San Zeno, Verona, and still in situ. It is
one of the great Renaissance altarpieces, and it marks an important turning point in the
history of painting from the late Gothic toward the new style. The figures in all three
panels are unified by a common architectural setting—an open-sided pavilion capped
by a heavy cornice, the elaborately decorated piers of which occupy what appears as
empty space above the figures in the drawing. Visible in the drawing's lower left and
right corners are the profiles of the bases of the columns of the frame.

The relationship of the figures to the overall format of the space is one of the most
important differences in composition between the drawing and the painting, and it
shows that the artist was toying with the idea of massing the figures to the left to reveal
an open gap to the right rather than spreading them evenly across the whole area, as
in the end result.

Mantegna is one of the great masters of the Renaissance in northern Italy. He
was especially absorbed by the then-current revival of art and letters that occurred
throughout much of Italy under the influence of classical models. His mature paintings
are imbued with this new fascination for the classical past.

Like nos. 8–9, 11–13, 16, 20, 22, 51, 59, 61, and 63, this drawing formerly
belonged to the dukes of Devonshire at Chatsworth House, England (see the *D*
collection mark, surmounted by a ducal coronet, that appears in the lower right of
this sheet and on most of the other drawings).

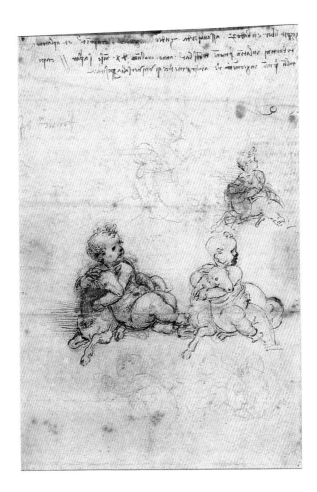

2　LEONARDO DA VINCI
Italian, 1452–1519
*Studies for the Christ Child
with a Lamb*

Pen and brown ink and black chalk
21 x 14.2 cm (8¼ x 5⁹⁄₁₆ in.)
Cat. II, no. 22; 86.GG.725

Leonardo probably made this drawing in preparation for a painting of the Virgin and Child with Saint John, now lost but known through copies, one of which is in the Ashmolean Museum, Oxford. Three of the studies in the present sheet are in ink, while another three are faintly drawn in black chalk. The number of different sketches for the same figure group indicates the painter's painstaking approach to the planning of his compositions. Leonardo, who was left-handed, inscribed the drawing at the top of the sheet and on the reverse in his characteristic mirror script, that is, with backwards writing.

Leonardo was the most versatile genius of the Italian Renaissance—a musician, scientist, inventor, and thinker as well as an artist. He must also rate as one of the greatest draftsmen in the history of Western European art, possessing prodigious powers of observation as well as great technical facility in various media.

He was born near Vinci, in Tuscany, and trained in Florence, where he spent his early career, before transferring to Milan (1481–99). He returned to Florence in 1500, where he remained, with interruptions, until 1506; it was in this period that he must have made the present drawing.

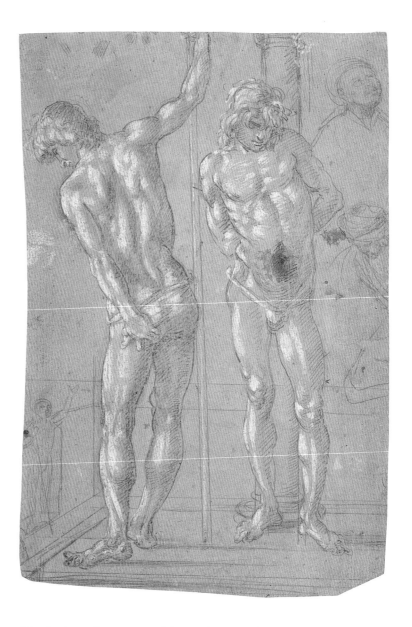

3 FILIPPINO LIPPI
Italian, 1457/58–1504
*Two Studies of a Nude Youth,
and Other Studies*

Metalpoint, heightened with white
bodycolor, on gray prepared paper
27.1 x 17.4 cm (10¹¹⁄₁₆ x 6⅞ in.)
Cat. III, no. 25; 91.GG.33 verso

Metalpoint, a forerunner of the modern graphite pencil, is an exacting medium, but one that allows for great delicacy of touch. It was in frequent use in the fifteenth and sixteenth centuries in Italy and the Netherlands (see, for example, no. 11). The ground, usually composed of powdered bones mixed with a water-based binder, was tinted and brushed on evenly over the paper to provide a coarse surface to receive the line from the point. As in this example, highlights were applied with the brush in Chinese White. The responsiveness of the material made it convenient for drawing from life.

The Florentine painter Filippino Lippi was trained by Sandro Botticelli, whose rhythmical use of line exerted a strong influence on him. In this drawing, the graceful poses of the figure and the decorative treatment of the drapery have the same expressiveness as some of the artist's late paintings, which are dramatic and even eccentric in their effects.

The studies of the nude youth were probably made to prepare the figure of Saint Sebastian in Lippi's altarpiece of *Saints Sebastian, John the Baptist, and Francis* (Genoa, Palazzo Bianco), 1503, one of his last works.

4 FRA BARTOLOMMEO
(Baccio della Porta)
Italian, 1475–1517
Madonna and Child with Saints

Black chalk, with some traces of
white chalk
37.4 x 28.2 cm (14¾ x 11⅛ in.)
Cat. I, no. 5; 85.GB.288

This is a study, with appreciable differences, for the unfinished altarpiece in monochrome
in the Museo di San Marco, Florence. Fra Bartolommeo had been commissioned in
1510 to paint the picture for the space in the middle of one of the long walls of the
Sala del Gran Consiglio of the Palazzo Vecchio, Florence, the council chamber of the
Florentine republic. It was to have divided the pendant wall decorations of the *Battle
of Anghiari* and the *Battle of Cascina,* which had earlier been commissioned from
Leonardo da Vinci and Michelangelo, respectively, though only Leonardo's painting
was ever started. Fra Bartolommeo explored his composition in a number of preparatory
studies, of which this is one of the finest and most complete.

Fra Bartolommeo briefly gave up painting when, in 1500, he became a monk, but
in 1504 he returned to his avocation.

5 MICHELANGELO
 BUONARROTI
 Italian, 1475–1564
 *The Holy Family with the Infant
 Saint John the Baptist* (*Rest on
 the Flight into Egypt*)

 Black and red chalk with pen and
 brown ink over stylus underdrawing
 28 x 39.4 cm (11 x 15½ in.)
 Cat. III, no. 29; 93.GB.51

Michelangelo treated the subject of the Virgin and Child many times during his long career—in painting and sculpture, as well as in drawing. Here he has chosen to represent an unusual variant of the theme, not specifically related in the Bible, according to which the infant Baptist and two angels join the Holy Family on an interlude in their flight into Egypt. The sculptural effect of the central group of the Virgin and two children is achieved both by a combination of different media drawn on top of each other—stylus underdrawing, red and then black chalk, followed by pen and brown ink—and by the finely modulated hatching and cross-hatching (shading). Especially the pen work shows the dynamism of the artist's creative process and the extent to which he changed his drawing as his ideas took shape. This is particularly evident in the head of the Virgin, which is rendered both looking downward to the left and upward to the right.

The drawing has been dated around 1530. Its purpose remains unknown, but it may be a sketch for a marble bas-relief. The composition certainly suggests realization in this medium, with the central group evidently in higher relief than the flanking figures. The motif of the Virgin suckling the Christ Child occurs in a sculpture by Michelangelo in the Medici Chapel, Florence, a commission on which he was engaged at about this time.

Michelangelo is one of the most outstanding personalities in the history of European art, unique in his fourfold supremacy as sculptor, painter, architect, and draftsman. Trained in Florence, he was in Rome in 1496–1501, where he sculpted the marble *Pietà* for the Basilica of Saint Peter. In 1508, Pope Julius II commissioned him to paint the ceiling of the Sistine Chapel, the private chapel of the popes in the Vatican, a work that must rank as the greatest masterpiece of Italian painting. In 1516, Michelangelo returned to Florence, where he was employed by the ruling Florentine family, the Medici. From 1520 onward he worked on the erection of their family chapel, known as the Sagrestia nuova (New sacristy), adjacent to one of the transepts of their Church of San Lorenzo, and on the construction of the Medici tombs inside.

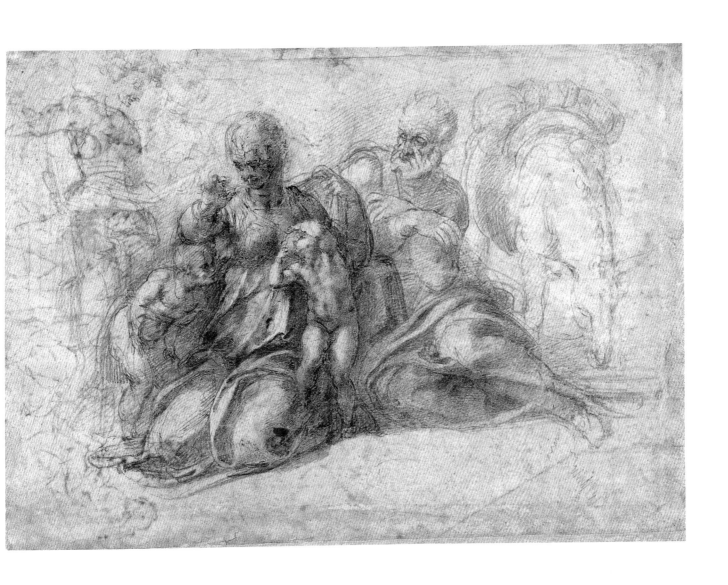

6 LORENZO LOTTO
 Italian, circa 1480–1556/57
 Saint Martin Dividing His
 Cloak with a Beggar

 Brush and gray-brown wash,
 white and cream bodycolor,
 over black chalk on brown paper
 31.4 x 21.7 cm (12⅜ x 8⁹⁄₁₆ in.)
 Cat. I, no. 20; 83.GG.262

The fourth-century Christian saint Martin of Tours was a preacher and the founder of
the first monasteries in France. He is usually dressed either as a Roman soldier or as a
bishop and is well known for the charitable act he is here shown performing—cutting
his cloak in two in order to share it with a naked beggar. In the drawing, the beggar
covers his body with his half as Saint Martin gazes down at him, sword in hand, his
own now-truncated part of the cloak billowing out protectively over the beggar's head.

 The steep perspective of the architectural background suggests that the
composition perhaps was intended for a painted organ shutter to be seen high above
the spectator. The lively movement of the figures, with the saint leaning steeply out of
the space, is characteristic of Lotto's invention, while typical of the artist's humor is the
knowing glint in the horse's eye, which a little disconcertingly captures the viewer's
attention.

 The drawing is unique in the artist's graphic work in being signed; [*Laur*]*entius
Lotus* appears on the reverse.

7 ANDREA PREVITALI
Italian, circa 1480–1528
Portrait of a Young Woman

Black chalk with some white chalk
34.7 x 25.9 cm (13¹¹⁄₁₆ x 10³⁄₁₆ in.)
Cat. III, no. 38; 94.GB.36

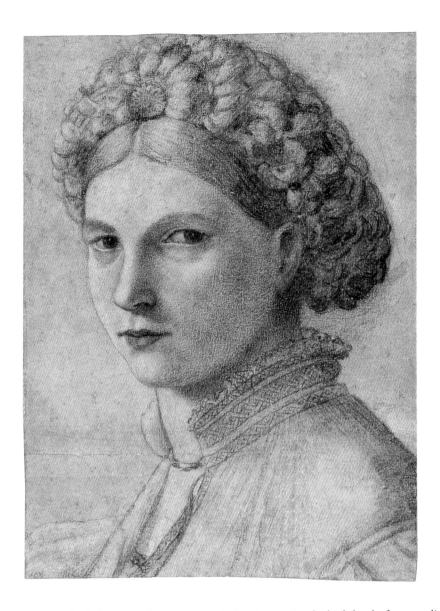

During the Italian Renaissance, portrait drawing attained a high level of accomplishment. In this example, the unidentified sitter gazes directly at the viewer. Her simple beauty contrasts with her rich costume, lace-trimmed blouse, and complicated coiffure. The latter, fashionable in the 1520s and 1530s, was known as a *cuffia* and was made of hair interwoven with ribbons and other decorations. Although the portrait was possibly made for a painting, it could equally well have been a work in its own right.

The attribution of the drawing is uncertain, but it is now usually given to the north Italian painter Andrea Previtali. Although there is no direct correspondence with any of Previtali's painted work, good general comparisons may be made with some of the female heads in his pictures.

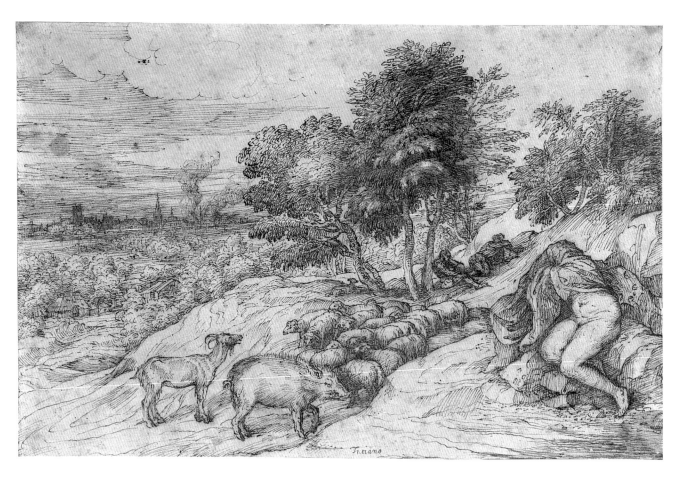

8 TITIAN
 (Tiziano Vecellio)
 Italian, circa 1480–1576
 Pastoral Scene

 Pen and brown ink, black chalk,
 with some corrections in white
 bodycolor in the trees
 19.6 x 30.1 cm (7¹¹⁄₁₆ x 11⅞ in.)
 Cat. I, no. 51; 85.GG.98

As the old inscription indicates, this magnificent finished landscape study is given by tradition to the great Venetian Renaissance painter Titian, whose drawings are rare. There are analogies of composition with certain details in his pictures, for example the background of *Venus and Cupid with a Luteplayer* (Cambridge, Fitzwilliam Museum).

The subject is enigmatic. The nude woman on the right with a drapery covering her head is incongruously juxtaposed with a flock of sheep, accompanied by a boar and a goat, tended by two shepherds resting beneath the clump of trees in the center. The pen work is smoothly and exquisitely handled, achieving an impressive variety of technical effects, the meticulous execution and concern for detail admirably suggesting the light, space, and different physical forms of the landscape.

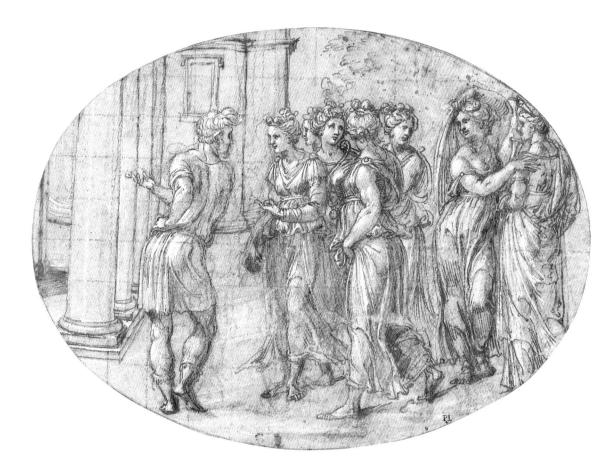

9 BALDASSARE PERUZZI
Italian, 1481–1536
*Odysseus and the Daughters
of Lycomedes*

Pen and brown ink, black chalk,
and white bodycolor heightening,
squared in black chalk
17.6 x 24.2 cm (6¹⁵⁄₁₆ x 9½ in.)
Cat. I, no. 30; 85.GG.39

The drawing appears to show the Greek warrior Odysseus, one of the heroes of the Trojan War, inviting the daughters of Lycomedes, King of Scyros, into a palace in a stratagem to discover which one of them is actually Achilles in disguise. It had been foretold to Thetis, Achilles' mother, that her son would die in the Trojan War. To prevent this from occurring, she dressed him as a maiden and sent him to live among the daughters of Lycomedes. To reveal Achilles' identity, Odysseus offered the daughters a selection of gifts—jewels, dresses, etc., together with a sword, spear, and shield. While the daughters were choosing, Odysseus ordered a trumpet blast and clash of arms to sound outside, whereupon Achilles betrayed himself by snatching up the weapons. At his discovery, Achilles immediately promised Odysseus his assistance in the war against Troy, in which he indeed met his death.

This is a sketch for one of the four oval frescoes Peruzzi painted in 1520–23 on the vault of the northeast cupola of the loggia of the Villa Madama, Rome. A second oval contains a fresco showing the discovery of Achilles.

The drawing is squared, that is, lightly ruled with a grid of squares in black chalk to allow the design to be transferred to another surface preparatory to painting. An enlarged grid, drawn to the same proportion as that in the sketch, was made on the picture surface, and the artist then copied in turn the configuration of lines within each square, thereby obtaining a remarkably accurate, enlarged replica of his design.

10 RAPHAEL
 (Raffaello Sanzio)
 Italian, 1483–1520
 Studies for the "Disputa"

 Pen and brown ink
 31.2 x 20.8 cm (12¼ x 8³⁄₁₆ in.)
 Cat. I, no. 38; 84.GA.920

This is a study for one of the figure groups in the left foreground of the *Disputa,* one of four frescoes in the Stanza della Segnatura of the Vatican, which together constitute one of the artist's great masterpieces. Raphael painted the room for Pope Julius II in 1509–11. Three of the scenes correspond to the faculties into which human knowledge was then organized, with the *Disputa* representing Theology. The composition juxtaposes serene and regularly arranged divine beings in a hemicycle above with the random groupings of theologians, around an altar, attempting to grasp the mystery of the Faith. The main figure in this study is for the so-called philosopher who in the finished fresco stands turned away from the spectator in the center of the group to the left of the altar. The handling of the drawing shows the extraordinary clarity and economy of Raphael's style.

Raphael was one of the great geniuses of the Italian High Renaissance, a short flowering of talent that occurred, principally in Rome, under the influence of classical models. He was preeminent both as a draftsman and as a painter.

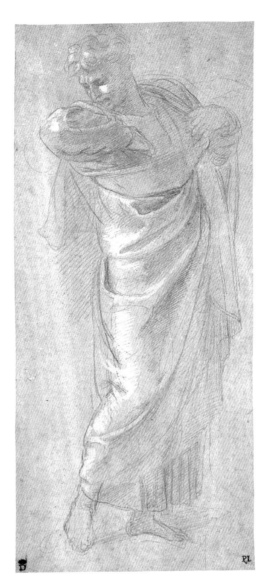

11 RAPHAEL
 (Raffaello Sanzio)
 Italian, 1483–1520
 Saint Paul Rending His Garments

 Metalpoint heightened with white
 bodycolor, on pale violet-gray
 prepared paper
 23 x 10.3 cm (9¹⁄₁₆ x 4¹⁄₁₆ in.)
 Cat. I, no. 39; 84.GG.919

This drawing is a study for the figure of Saint Paul in the cartoon of the *Sacrifice at Lystra,* one of seven surviving cartoons representing scenes from the lives of Saints Peter and Paul, now in the Victoria & Albert Museum, London. Cartoons are full-sized drawings made at the end of the preparatory process to transfer the outlines of the composition onto the surface to be woven or painted, either by pricking through the outlines or by indenting them with a stylus (this latter method being possible only for the transfer to a surface harder than linen).

Pope Leo X had commissioned Raphael to make the cartoons for a series of ten tapestries to decorate the lower walls of the Sistine Chapel in the Vatican. The tapestries were woven from the back, so the design of the cartoons is the reverse of the final result. The figure in this drawing thus appears in the opposite direction in the tapestry in the Vatican.

Saint Paul tore his garments in anger at the people of Lystra, who, following his healing of a crippled man, prepared a sacrifice to him and Saint Barnabas, thinking that they were Mercury and Jupiter come down to earth as men. When the priest of Jupiter brought oxen and garlands for sacrifice, the apostles "rent their clothes, and ran in among the people, crying out" (Acts, 14:14).

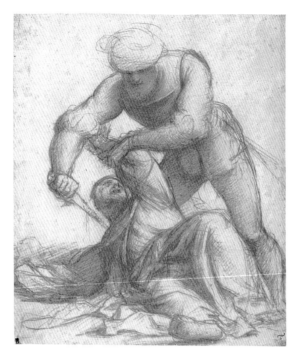

12 PORDENONE
(Giovanni Antonio de' Sacchis)
Italian, 1483/84–1539
Martyrdom of Saint Peter Martyr

Red chalk
24.4 x 20.7 cm (9⅝ x 8⅛ in.)
Cat. II, no. 36; 87.GB.91

The subject of this extraordinarily powerful drawing is the gruesome death of Saint Peter Martyr, a thirteenth-century Dominican saint renowned for the officious zeal with which he pursued heretics. He was murdered by assassins hired by two Venetian noblemen whom he had caused to be imprisoned by the Inquisition.

The study is connected with Pordenone's finished compositional drawing of the subject in the Galleria degli Uffizi, Florence, 1526–28, which demonstrates that he, along with Palma Vecchio, competed with Titian for the commission to paint an altarpiece of the *Assassination of Saint Peter Martyr* for the Venetian Basilica of Santi Giovanni e Paolo. Titian was awarded the contract. His picture, completed in 1530, perished in a fire in 1867.

13 CORREGGIO
(Antonio Allegri)
Italian, 1489/94–1534
Christ in Glory

Red chalk, brown and gray wash, heightened with white bodycolor (partly oxidized), lightly squared in red chalk, on a pink ground; circle inscribed in brown ink
14.6 x 14.6 cm (5¾ x 5¾ in.)
Cat. II, no. 15; 87.GB.90

This is a *modello* (finished sketch) for the medallion, supported to each side by two pairs of standing nude putti (child angels), in the center of the underside of the entrance arch to the del Bono Chapel in the Church of San Giovanni Evangelista, Parma; the execution of the decoration is generally dated 1520–23. Correggio had previously painted his famous decoration of the cupola and pendentives of the crossing in 1520–21. Correggio, the leading Renaissance painter of the school of Parma, was renowned for the gracefulness and sensuousness of his figures. He adopted Leonardo's *sfumato* (muted) effects and was influenced by Michelangelo. In the present drawing, something of the "softness" of Correggio's paintings is conveyed by the creamy treatment of light. The attractive range of pinks that results from the combination of red chalk and white heightening is also characteristic of the pictorialism of Correggio's draftsmanship.

14 PONTORMO
(Jacopo Carrucci)
Italian, 1494–1557
Dead Christ

Black and white chalk
28.4 x 40.5 cm (11³⁄₁₆ x 15¹⁵⁄₁₆ in.)
Cat. I, no. 35; 83.GG.379

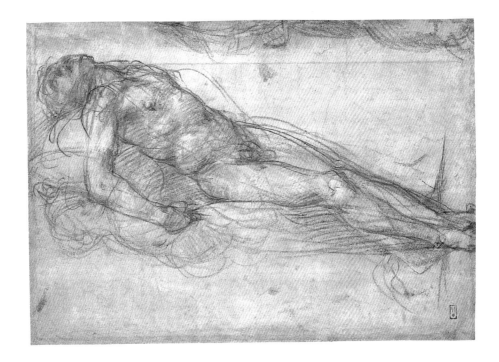

This study belongs with a group of other drawings by Pontormo for the same figure in the Galleria degli Uffizi, Florence, and in Rotterdam. They are connected with a *Pietà,* the central panel of a *predella* (the series of small paintings sometimes grouped beneath an altarpiece), in the National Gallery of Ireland, Dublin. The exact purpose of the predella remains a matter of speculation, but it may have been intended to decorate the base of Pontormo's early altarpiece of the *Madonna and Child with Saints* in the Church of San Michele Visdomini, Florence, painted in 1518. The predella, which is partly based on drawings by Pontormo, must, however, have postdated the altarpiece by several years and may well have been executed by an assistant. This identification of the connection of the drawing is supported by the study for a figure of Saint Francis on the other side of the sheet, which is unquestionably for one of the figures in the Visdomini altarpiece.

With the drawing turned clockwise ninety degrees, it is possible to see more clearly a study for a woman standing in profile to the right drawn below the figure of Christ. This relates to a fragment of another study for this same figure cut off to the right by the edge of the sheet.

Pontormo is regarded as a leading exponent of the anticlassical style known as Mannerism, which followed the High Renaissance. The term was first coined as an expression of disfavor to emphasize what was generally thought to be the decline that had taken place in Italian art immediately following its period of greatest achievement. Pontormo's work typifies this early phase of Mannerism, and it is true that the emotional intensity of much of his painting and drawing strikes a contrast with the harmonious, classical ideal that had gone before.

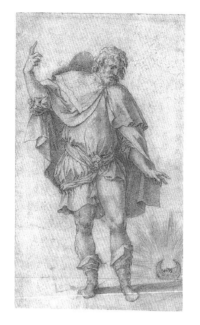

15 ROSSO FIORENTINO
(Giovanni Battista di Jacopo
di Gasparre)
Italian, 1495–1540
Empedocles

Red chalk with black chalk in the
horizon line, the outlines gone over
with the stylus for transfer
25.1 x 14.8 cm (9⅞ x 5¹³⁄₁₆ in.)
Cat. I, no. 43; 83.GB.261

The drawing has been dated around 1538–40.
The figure appears in reverse in a print based on it
by the French engraver René Boyvin, datable in the
1550s. Empedocles (fl. circa 444 B.C.) came from
Agrigentum in Sicily. Although of wealthy stock,
he took part in the revolution that removed
Thrasydaeus, the son and successor of the tyrant of
Agrigentum, Theron. In establishing a democratic
political order, Empedocles zealously supported the
poor and persecuted the overbearing conduct of
the aristocrats. He was an orator and naturalist,
who through penetrating knowledge of the natural
world gained a reputation for curative powers, even being credited with the ability to
avert epidemics. It is therefore not surprising that in this representation of him Rosso
should have suggested certain analogies with the attributes of Saint Roch, the Christian
saint frequently invoked for protection against the plague.

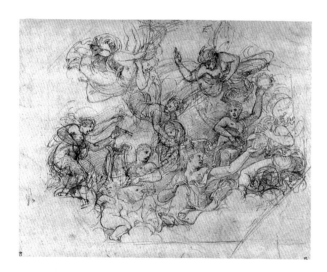

16 GIULIO ROMANO
(Giulio Pippi)
Italian, (?)1499–1546
*An Allegory of the Virtues
of Federigo II Gonzaga*

Pen and brown ink over black chalk,
with some highlights and corrections
in white bodycolor
24.9 x 31.8 cm (9¹³⁄₁₆ x 12½ in.)
Cat. I, no. 15; 84.GA.648

In 1526, commissioned by Federigo Gonzaga, Giulio Romano
began the construction of the Palazzo del Te in Mantua, the
Gonzaga family's new residence, which was one of the first
Mannerist buildings deliberately to flout the canons of classical
architecture.

This drawing is a design for the fresco for the octagonal
central compartment of the ceiling of the Sala d'Attilio Regolo
of the Casino della Grotta in the garden of the palace. This part
of the palace was built around 1530, and the decoration was
completed by 1534.

The composition shows a personification of the city of
Mantua seated at the center receiving various attributes from
attendant figures, an allusion to the good governance of the city
under Federigo. The many *pentimenti* (corrections) and the hurried pace at which the
drawing was made show that at this stage the composition was still evolving in the
artist's mind. An earlier study of the scene is in the Department of Prints and Drawings
at the British Museum, London, and a final *modello* (see no. 13) is in the Musée du
Louvre, Paris.

Giulio, a painter and architect, was born in Rome, where he was Raphael's chief
pupil and assistant. By 1524 he had moved to Mantua, where he remained for the rest
of his life, in the service of the Gonzaga court. The style of the painting and drawing
reveal his indebtedness to Raphael.

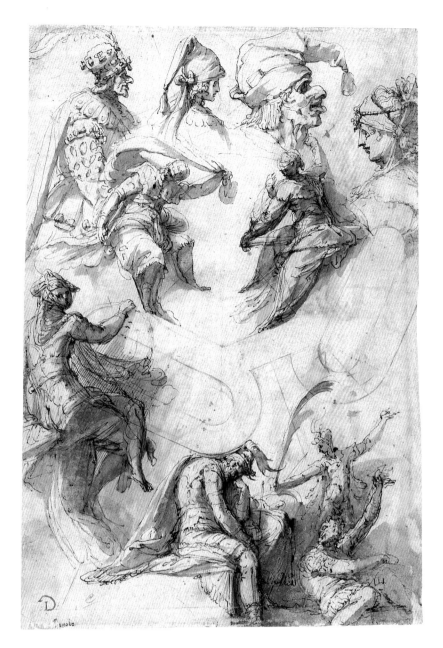

17 PERINO DEL VAGA
(Pietro Buonaccorsi)
Italian, circa 1500–1547
Studies of Figures and Architecture

Pen and brown ink, brown wash,
and black chalk, some of the outlines
indented for transfer
32.7 x 22.5 cm (12⅞ x 8¾ in.)
Cat. II, no. 30; 88.GG.132

The architectural design first drawn on the sheet corresponds to the pattern of part of the richly decorated coffered barrel vault of the Sala Regia in the Vatican, Rome, the hall located at the principal entrance to the Sistine Chapel and intended for the papal reception of sovereigns. The architect Antonio da Sangallo the Younger began the room in 1540, and the vault was completed in 1542–45. At Sangallo's death, Perino was given charge of the decoration of the space, including the frescoes on the walls, a task cut short by his own death the following year.

The inscription *Tiepolo* in the lower left corner demonstrates that a previous owner of the drawing believed it to be by the eighteenth-century Venetian painter Giovanni Battista Tiepolo, who was active nearly two hundred years after Perino. No doubt the liveliness of the figures, with their festive costumes, and the fluency of the washes suggested the work of the later master. The error provides a salutary reminder of just how easily the true authorship of Old Master drawings may be lost, and how tenuous are some attributions unless backed up by a specific connection with a documented work.

18 PARMIGIANINO
(Francesco Mazzola)
Italian, 1503–1540
*Saints John the Baptist, Jerome,
and Two Other Saints*

Red chalk
15.1 x 22.1 cm (5¹⁵⁄₁₆ x 8¹¹⁄₁₆ in.)
Cat. II, no. 28; 87.GB.9

This drawing is generally connected with Parmigianino's famous altarpiece the
Madonna and Child with Saints John the Baptist and Jerome (the so-called *Vision of
Saint Jerome*) in the National Gallery, London. Parmigianino was working on the
altarpiece in Rome in 1527 when the city was occupied by the army of Charles V prior
to its sacking. The sixteenth-century artist biographer Giorgio Vasari reports that the
soldiers entered the painter's studio, admired the picture, but then left Parmigianino in
peace to pursue his work.

Since there are many differences between this drawing and the painting, it is now
believed that the drawing is for the composition of an earlier altarpiece, either lost or
never executed, that must have been similar in several respects to the London picture.
The style of the drawing certainly suggests an earlier dating, toward the beginning of
the 1520s, as does the presence on the other side of the sheet of a study for one of the
dogs in the fresco *The Story of Diana and Actaeon,* on the ceiling of a room in the
Rocca Sanvitale at Fontanellato (near Parma), painted in about 1523.

Parmigianino was a leading painter of the Mannerist style (see no. 14) and is well
known for the somewhat unsettling emotional intensity of his paintings, with their
elongated figures, compact space, and chilly effects of light.

19 GIOVANNI GIROLAMO
SAVOLDO
Italian, active 1508–1548
Saint Paul

Black, white, and red chalk on blue
paper; sheet cut irregularly at the
sides and top
28.3 x 22.6 cm (11³⁄₁₆ x 8⁷⁄₈ in.)
Cat. II, no. 45; 89.GB.54

This is a study for the head of Saint Paul in the altarpiece of the *Madonna and Child in Glory with Saints* in the Church of Santa Maria in Organo, Verona. The altarpiece was painted by Savoldo and his workshop in 1533; another, perhaps finer, version of the picture is in the Pinacoteca di Brera, Milan. The downturned gaze, profuse black beard, and baleful expression give the head an air of melancholy, though at the same time a sense of nobility is conveyed by the strength of the features, the somberness of the tones, and the felicity of the occasional white highlights.

The drawing would appear to be a full-sized *modello* (see no. 13). Not only does the head correspond closely in size to its painted counterpart, but there are exact similarities of outline and lighting. Such a study would have been made late in the preparatory process. The fact that the sheet is cut irregularly at the top and is somewhat damaged might suggest that it was taken from a cartoon (see no. 11).

20 PAOLO VERONESE
(Paolo Caliari)
Italian, 1528–1588
The Martyrdom of Saint Justina

Pen and gray ink, gray wash,
heightened with white bodycolor on
(faded) blue paper; squared in black
chalk
47 x 24 cm (18½ x 9⁷⁄₁₆ in.)
Cat. II, no. 49; 87.GA.92

Justina of Padua was a Christian martyr who is reputed to have died under the persecutions of Emperor Maximian of Rome (A.D. 305–11). This highly finished and beautiful *modello* (see no. 13) was made in preparation for the altarpiece painted by Veronese and his studio in 1574–75 for the Church of Santa Giustina in Padua, built in the fifth century on the site of the saint's martyrdom and restored by the Benedictines in the sixteenth century. With a sword piercing her breast, Justina is represented as a richly dressed young princess surrounded by her tormentors, including two Roman soldiers standing to the left, while putti descend from heaven bearing her martyr's crown and palm.

The creamy white bodycolor, applied with the point of the brush, is extraordinarily sensitive and varied in its effect—from the thickly painted, brilliant white light of the heavens, in the upper part of the drawing, to the more thinly applied highlights in the draperies of the figures below. The drawing is squared (see no. 9).

Veronese, who, as his name suggests, came from Verona, was one of the great painters of the late Venetian Renaissance. His attractive use of color, his fondness for rich ornament, together with the inventiveness of his compositions and the relaxed demeanor of his figures, anticipate eighteenth-century Venetian painting. He was influenced by the great Venetian of an older generation, Titian.

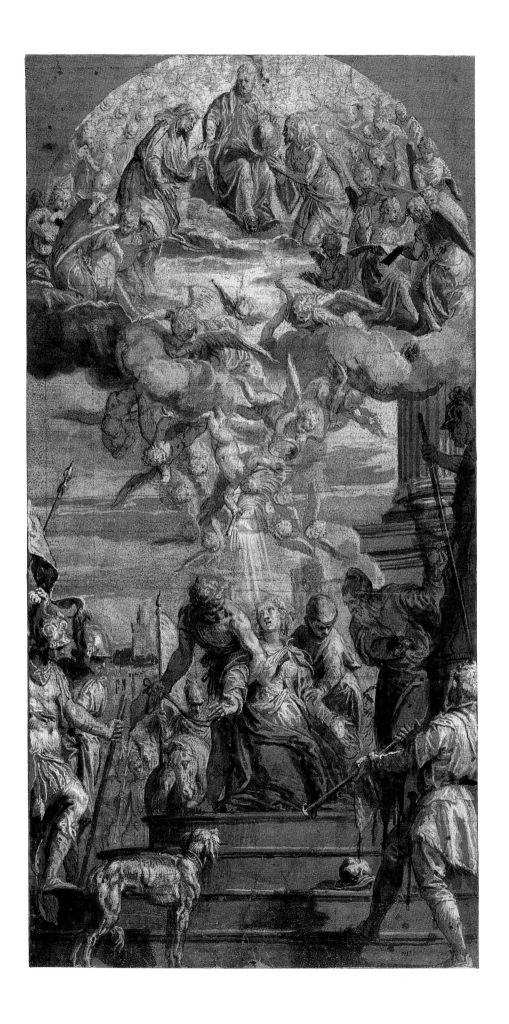

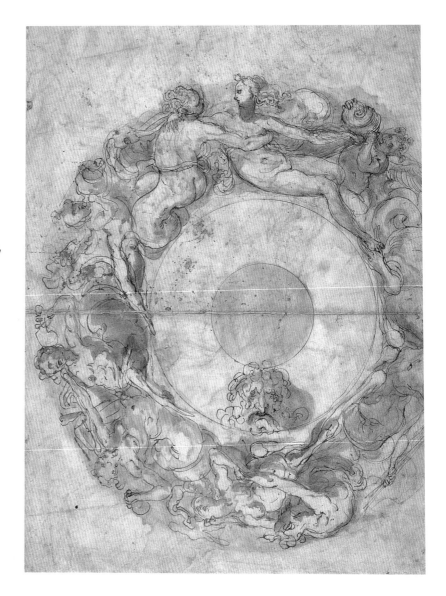

21 TADDEO ZUCCARO
Italian, 1529–1566
Design for a Circular Dish with Marine Deities

Pen and brown ink and brown wash
over stylus underdrawing
35.3 x 26.3 cm (13⅞ x 10⅜ in.)
Cat. III, no. 55; 91.GG.58

The sea monsters in the border are shown both fighting and embracing each other, while, as if from the ocean's deep, a large bearded head (Neptune?) gazes up from part of the bowl's recess; as the contents of the vessel emptied, his presence would have become gradually more apparent. The design was almost certainly made for a circular dish or salver, to be carried out in metalwork. It was not uncommon in sixteenth-century Italy for important artists to be employed in the design of such applied-art objects. Taddeo Zuccaro made other similar designs not only for metal salvers but also for *majolica* (earthenware with colorful painted decoration, wholly or partly coated with a glaze containing tin, which makes it white and opaque), including a service with scenes from the life of Julius Caesar intended as a present from the Duke of Urbino to the King of Spain. The sheet may be dated 1553–56 because of the studies on the reverse for Zuccaro's frescoes in the Mattei Chapel of the Church of Santa Maria della Consolazione, Rome, where he worked at that time.

Taddeo Zuccaro worked in an extravagant late Mannerist style. His figures often strike impossibly contorted poses; at the same time, there is an element of humor to his inventions.

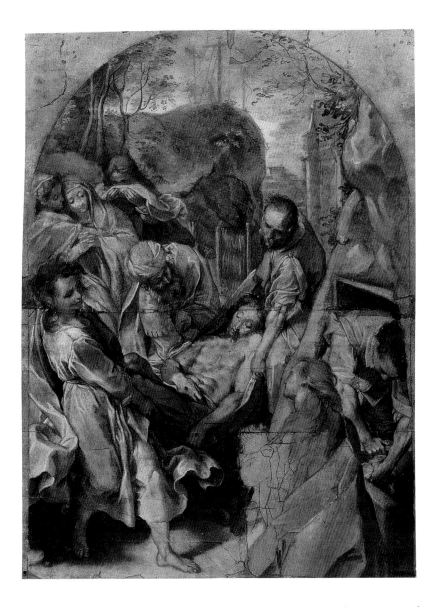

22 FEDERICO BAROCCI
Italian, circa 1535–1615
The Entombment

Oil over black chalk
on prepared paper
47.7 x 35.6 cm (18¹³⁄₁₆ x 14 in.)
Cat. I, no. 3; 85.GG.26

This sketch is preparatory to Barocci's altarpiece of the *Entombment,* painted in 1579–82 for the Church of Santa Croce, Senigallia, and still in situ. The artist opted for oil rather than the more usual media associated with works on paper, such as chalk or pen and brown wash, to enable him to judge the effect of different colors on his composition (for another work in oil on paper, see no. 90). In the present sketch, Barocci has left unfinished the kneeling figure of Saint Mary Magdalene in the right foreground, though the saint appears in much the same pose and in roughly the same position vis-à-vis the other figures in the composition, in both the *modello* at Urbino and the finished altarpiece.

Barocci is known for his painstaking working method and extensive use of drawing to prepare his pictures. Once the form of a given composition had been reached, he then proceeded to make several studies, usually in black-and-white chalk on light-blue tinted paper, for each of the figures, including separate studies of the limbs and head, before going on to make fully worked up sketches of the composition, such as this one, and, eventually, the cartoon (see no. 11). His paintings, which display a fine sense of color, admirably capture the new pathos of the Counter-Reformation by their tenderness of feeling.

23 JACOPO ZUCCHI
Italian, circa 1540–1596
The Age of Gold

Pen and brown ink with brown and
ocher wash, heightened with white
bodycolor
48 x 37.8 cm (18⅞ x 14⅞ in.)
Cat. I, no. 57; 84.GG.22

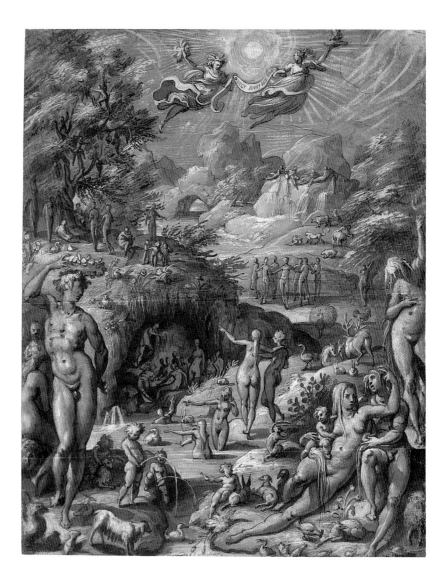

This impressive sheet is a finished compositional study, with numerous differences
of detail, for the small-scale picture on panel in the Galleria degli Uffizi, Florence,
probably painted around 1570. The Golden Age was the first of the four ages of the
world in classical mythology. It followed immediately after the Creation and was an
earthly paradise somewhat akin to the Christian Garden of Eden. The happiness of this
golden time is implicit in the peaceful co-existence of human and animal kind, as well
as in the freedom that permits, for example, the two little boys, lower left, to urinate
competitively into the flowing brook, downstream from the group of bathing nude
women and almost directly onto a nearby duck.

The literary inspiration for Zucchi's design was a text by the scholar Vincenzo
Borghini, written about 1565–67. Two Florentine painters contemporary with Zucchi,
Giorgio Vasari and Francesco Morandini, called Poppi, also illustrated the text—Vasari
in a drawing in the Musée du Louvre, Paris, and Poppi in a painting in the National
Gallery of Scotland, Edinburgh.

24 JACOPO LIGOZZI
Italian, circa 1547–1627
Soldier with Cheetah

Brush, pen and brown ink,
bodycolor, and painted gold
28.1 x 22.3 cm (11⅟16 x 8¾ in.)
Cat. III, no. 24; 91.GG.53

Inscribed by the artist top left: *AZAPPI/ Sonno gli Soldati de Galera* (Azaps/They are the galley soldiers); and lower right: *Leopardo*. The term *azappo* comes from the Turkish word *azap* (marine), which helps to clarify the following phrase. These archers were seafaring soldiers employed on Turkish galleys or longboats. This is one of a series of drawings, the majority of which are in the Galleria degli Uffizi, Florence, done with the brush in brightly colored bodycolor; they show Turks, mostly accompanied by exotic animals, as in this example. The purpose of the drawings is unknown, but they were evidently inspired by the engraved illustrations in the book *Le navigationi et viaggi nella Turchia,* 1580, by Nicolas de' Nicolai. The precise, miniaturist style is typical of Ligozzi's work; it was well suited to the commission on which he was employed by Francesco I de' Medici, which included detailed drawings of the Medici zoological and botanical collections.

Ligozzi was employed as painter to the grand-ducal court in Florence as well as designer of tapestries and glass engravings and superintendent of the picture gallery. He also painted on a large scale and completed paintings for the Palazzo Vecchio as well as altarpieces for churches in Florence and elsewhere. His colored drawings must rank among his finest work.

25 AGOSTINO CARRACCI
Italian, 1557–1602
Group of Figures in an
"Adoration of the Shepherds"
and Other Studies

Pen and brown ink
40.5 x 30.8 cm (15¹⁵⁄₁₆ x 12⅛ in.)
Cat. II, no. 12; 86.GA.726

The principal study, a group of shepherds with their children and animals, was employed with little variation in a lost painting of the *Adoration of the Shepherds* by Agostino's brother Annibale; the appearance of that painting, however, survives in a copy by Annibale's pupil Domenichino (Edinburgh, National Gallery of Scotland).

The antique-style cameo of three bearded men in profile above the main study is a caricature, though the identity of the heads remains unknown (for a similar cluster of caricature heads in profile by the French nineteenth-century painter Degas, see no. 91). Striking the same slightly jocular note are the head of a man with a wispy beard, center right (evidently the same person as on the left in the cameo), and the diminutive head of a cat, in the right corner, which stares out somewhat disconcertingly at the spectator.

With his cousin Lodovico and brother Annibale, Agostino was one of the three Carracci who were jointly responsible for the "reform" of Italian painting at the end of the sixteenth century. The new style they established rejected the artificiality of the preceding Mannerist style of painting (see no. 14) and returned more strongly to the study of nature and the antique, as in the High Renaissance period. The Carracci founded an academy of painting in Bologna, which had wide influence.

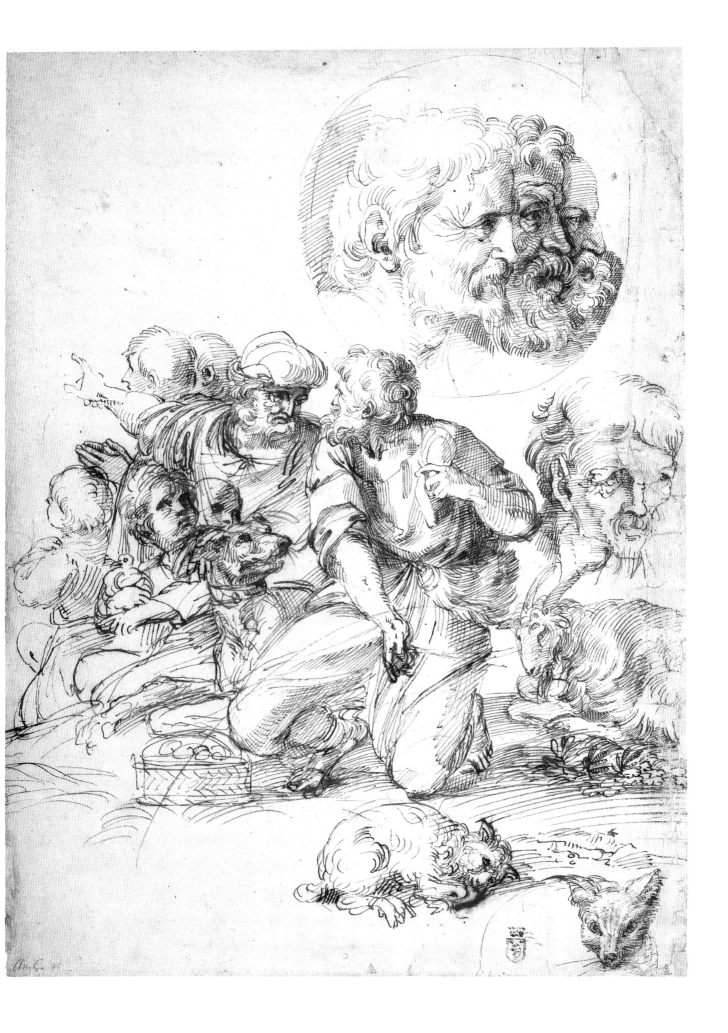

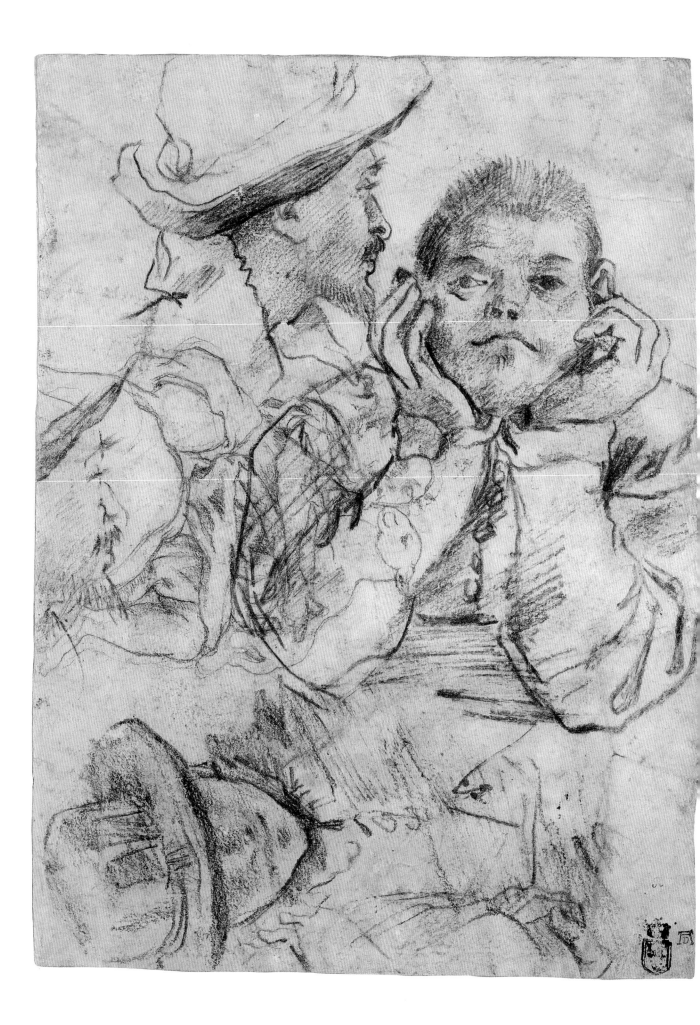

26 ANNIBALE CARRACCI
Italian, 1560–1609
Four Studies of Heads Drawn over a Copy of a "Saint John the Evangelist" by Correggio

Black chalk
27.7 x 20.7 cm (10⅞ x 8⅛ in.)
Cat. I, no. 8; 85.GB.218

A certain informality in Annibale's character made him fond of representing subjects from everyday life. In this sheet he has drawn a bearded man wearing a hat seen in profile to the right (the two studies top and center left); a youth with his head cupped in his hands, seen full face (right); and (at the bottom, with the sheet turned clockwise ninety degrees) a youth wearing a hat and gazing downward. The sketches are done over a faint tracing after a figure group by Correggio. The haphazardness of the sequence of studies and the rawness of their handling reflect the same unconventional streak in his makeup. The present study, which probably dates from the 1580s, illustrates Annibale's ability to make "snapshots" of his companions and to do so with great liveliness and force.

Annibale was without question the most talented and original of the three Carracci (see no. 25). He assimilated the best of High Renaissance influences, combining these with motifs drawn from nature, to his own invention. He worked in his native Bologna until 1595, when he transferred to Rome to work for the Farnese family. There he painted his masterpiece, the ceiling decoration of the Gallery of the Palazzo Farnese, 1597–1600. Together with Michelangelo's Sistine Chapel ceiling and Raphael's Vatican Stanze, the Farnese Gallery ceiling ranks among the greatest works of Italian painting.

27 DOMENICHINO
(Domenico Zampieri)
Italian, 1581–1641
Saint Cecilia

Black and white chalk on gray paper,
the outlines pricked for transfer
46.7 x 34.2 cm (18⁷/₁₆ x 13½ in.)
Cat. III, no. 15; 92.GB.26

The Christian saint and virgin martyr Cecilia is thought to have lived in the second or third century. When she married the Roman nobleman Valerius, she persuaded him to accept sexual abstinence and to convert to Christianity. She and Valerius were eventually martyred by the Roman governor. She is the patron saint of music, an association that stems from the fact that music was played on her wedding day. The cult of Saint Cecilia was strong in early seventeenth-century Rome following the sensational disinterment of her body from beneath the altar of the Church of Santa Cecilia in Trastevere in 1599, when she was found to be miraculously preserved.

The head corresponds to that of Saint Cecilia in the fresco of *The Glorification of Saint Cecilia* on the vault of the second chapel on the right, the Cappella Polet, in the Church of San Luigi dei Francesi, Rome, which Domenichino decorated in 1612–15. The saint is shown in ecstasy, being carried up to heaven by putti. The pricked outlines and the fact that the sheet is made up of four pieces of paper, with a join going across the center of the face, show that this must be a fragment of a cartoon (see no. 11). There is, however, also a complete cartoon for the same decoration in the Musée du Louvre, Paris, in which the saint's head corresponds more closely to the fresco than does this fragment. The supposition must be that Domenichino was dissatisfied with his first cartoon and decided to make another.

28 BERNARDO STROZZI
Italian, 1581–1644
Saint Francis

Black and white chalk
38.9 x 25.9 cm (15⁵⁄₁₆ x 10³⁄₁₆ in.)
Cat. III, no. 47; 91.GB.40

In an age so accustomed to photography as well as to all kinds of sophisticated
black-and-white and color reproductions, it is hard to imagine life without the camera.
But for the majority of artists, right up until the middle of the nineteenth century, the
most convenient way of preserving the appearance of a given object was to copy it, very
often by making a drawing on paper. Thus, the French painter Claude Lorrain (see no.
70) made an entire album of drawn records of his own pictures, the *Liber veritatis*
(Book of truth), now in the British Museum, partly to keep track of the ownership of
his paintings and partly to combat the efforts of forgers mimicking his designs. Although
usually less methodical in this respect than Claude, other artists kept sketchbooks of
ricordi (literally, records, or copies) that allowed them to remind themselves of a picture
or some detail in such a picture that had long since been dispatched.

Strozzi may have made this drawing as a record of his *Saint Francis in Adoration
before the Crucifix,* 1618–20 (versions in Genoa, Palazzo Rosso, and Tulsa, Philbrook
Museum of Art). The fact that the drawing corresponds so exactly to the painted head
and is finished in such detail, with the lights and darks noted with utmost care, suggests
that Strozzi had his own picture in front of him when making this sketch.

29 GUERCINO
(Giovanni Francesco Barbieri)
Italian, 1591–1666
Seated Youth

Oiled black chalk or charcoal,
heightened with white chalk
57.2 x 42.5 cm (22⁹⁄₁₆ x 16¾ in.)
Cat. II, no. 20; 89.GB.52

The studies Guercino made in his youth from living nude models are masterly in their suggestion of light, their confident handling, and their economic simplification of form. In these drawings he often used oiled charcoal (charcoal soaked in oil, thereby making the line darker as well as more permanent), with occasional touches of white chalk for the highlights, on rough, light-brown paper. The technique enabled him to create the effect of reflected light within deep shadow, as well as to suggest the texture of flesh.

In the sixteenth and seventeenth centuries, drawings from the nude of this type were called "academies" because they were done in the artist's studio, or academy. In 1616, the young Guercino took the bold step of setting up his own school of life drawing from the nude in Emilia. In doing so, he was deliberately aligning himself with the tradition of the famous Carracci (see nos. 25, 26), pioneers of the academic discipline for artists. The large-scale drawings from the nude that Guercino made were probably done as demonstration pieces to inspire his pupils. This supposition is reinforced by the fact that the model who sat for this drawing reappears in some of Guercino's other nude studies of the period, also done in the same oiled charcoal technique.

Guercino's painting continued the "naturalistic" style established in Italy by the Carracci family. At the outset of his career, Guercino employed a forceful style using dramatic light, saturated colors, and broad and vigorous brushwork. As his work progressed, his style became more classical in feeling.

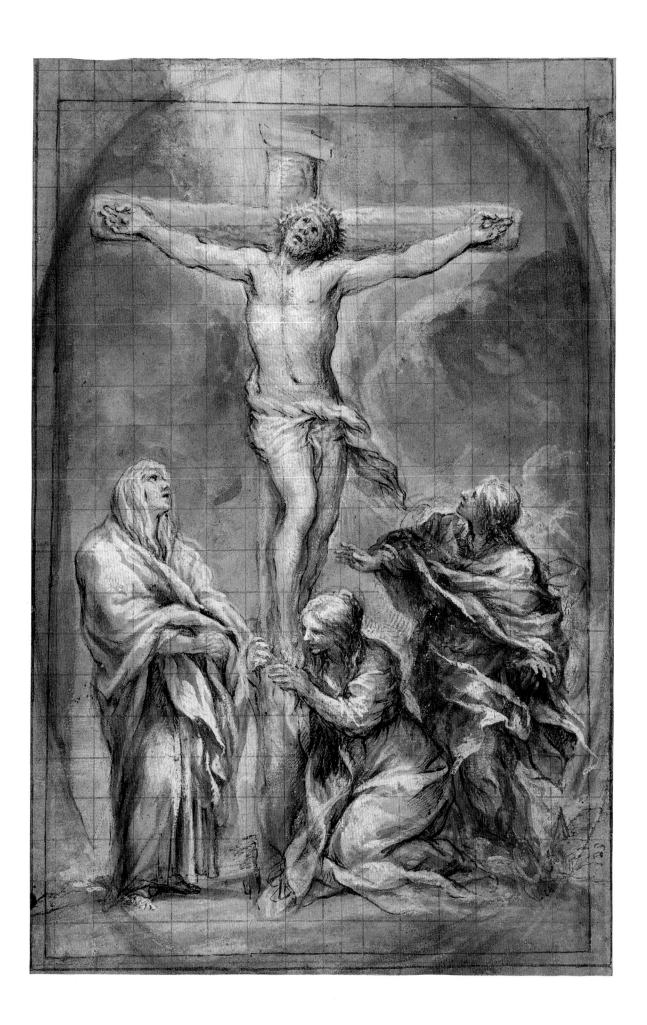

30 PIETRO DA CORTONA
(Pietro Berrettini)
Italian, 1596–1669

Christ on the Cross with the Virgin Mary, Mary Magdalene, and Saint John

Pen and brown ink, with gray-brown wash, heightened with white bodycolor over black chalk, on light-brown paper; squared in black chalk, with an oval drawn in red chalk
40.3 x 26.5 cm (15⅞ x 10⁷⁄₁₆ in.)
Cat. III, no. 35; 92.GB.79

In 1658–61, the great Italian Baroque sculptor and architect Gian Lorenzo Bernini constructed a new church in honor of the then recently canonized Saint Thomas of Villanova adjacent to the papal palace at Castelgandolfo, the pope's summer residence outside Rome. Cortona's elaborate, finished study is a design for the oval picture he painted, probably in the year of the building's completion, for the richly decorated high altar of the church, executed and embellished by Bernini's pupil Antonio Raggi. The composition of the altarpiece differs from the drawing in only a few respects.

The sheet is executed in Cortona's characteristically rugged manner, with extensive use of white heightening. The opaqueness of the white allowed him to conceal some of his earlier attempts at drawing the figures, especially the Saint John, which is bordered by a penumbra of white that covers earlier positions for the right and left arms, the head, and the left leg. The drawing is squared for transfer (see no. 9).

Cortona was a great architect and the most important painter of the Italian High Baroque style in Rome. He is best known for his famous illusionistic ceiling decoration in the *gran salone* (great hall) of the Palazzo Barberini in Rome, which he completed in 1639. The profusion of figures, the brilliance of color, and the overall complexity of that composition, with its interlocking scenes around a central opening to the sky, epitomize the exuberance of the High Baroque.

31 GIAN LORENZO BERNINI
Italian, 1598–1680

*Design for a Fountain, with a
Marine God Clutching a Dolphin*

Black chalk
34.9 x 23.8 cm (13¹¹⁄₁₆ x 9⅜ in.)
Cat. II, no. 5; 87.GB.142

Bernini was an architect and a painter as well as the most successful Italian sculptor
of his day. In 1650 Duke Francesco I d'Este of Modena had successfully persuaded
Bernini to make his portrait bust, which was completed the following year (Modena,
Galleria Estense). So pleased was the duke with the flamboyant likeness of himself that,
in 1652–53, he asked Bernini to submit drawings for a fountain to embellish the
d'Este family palace at Sassuolo. This powerfully evocative design is for the fountain
of Neptune, which is still in situ in the courtyard of the palace. The liveliness of the
figure as it struggles with the dolphin is typical of Bernini's vigorous, High Baroque
style. Framed in a niche, whose edges are indicated on either side of the drawing, the
fountain was executed by Bernini's assistant Antonio Raggi. A more finished studio
drawing for the project is in the Victoria & Albert Museum, London.

32 SALVATOR ROSA
Italian, 1615–1673
The Dream of Aeneas

Black and white chalk; the principal
outlines gone over with a stylus for
transfer of the design to a copperplate
30 x 22.3 cm (11¹³⁄₁₆ x 8¹³⁄₁₆ in.)
Cat. I, no. 42; 83.GB.197

The subject of this drawing is taken from Virgil's *Aeneid* (8.26–34). Aeneas, recently arrived in Latium and apprehensive about the forthcoming war with the Latins, rests on a riverbank. As he dreams, the river god Tiber rises from the waters "with azure mantle and with sedge-crowned hair" and comforts him. The composition corresponds closely to that of Rosa's painting of the subject in the Metropolitan Museum of Art, New York, which is generally dated about 1663–64. The drawing was not, in fact, used for the picture but as the model for an etching, which reverses the design but is otherwise identical except for the smallest details. This and another etching, *Jason Charming the Dragon,* are of about the same date as the painting.

The Neapolitan painter and etcher Salvator Rosa, who was a poet and musician as well as an artist, was one of the more eccentric of the many painters active in Rome in the mid-seventeenth century. An apparently apocryphal nineteenth-century tradition relates that, in his youth, he joined a group of *banditti* (bandits) who infested the Abruzzi Mountains east of Rome, a story given as explanation for his specialization in so-called robber pictures—tempestuous landscapes featuring wayfarers and *banditti.* His colorful personality, literary turn of mind, and confident belief in his own genius made him an important prototype of the Romantic artist.

33 CARLO MARATTI
Italian, 1625–1713

Faith and Justice Seated on Clouds

Pen and brown ink and brown wash over red chalk, heightened with white bodycolor, on brown paper, cut irregularly
48.4 x 28.7 cm (19¹⁄₁₆ x 11⁵⁄₁₆ in.)
Cat. I, no. 23; 85.GG.41

This is a study, in reverse but to the same scale, for the title frame of a map of Rome published in 1676 by Giovanni Giacomo de' Rossi. The map itself was carried out to the design of the seventeenth-century topographical artist Giovanni Battista Falda, while the ornamental title, to which this drawing corresponds, was Maratti's invention. Of the pair of figures, Faith (one of the three "theological virtues") is the more dominant. Crowned with the papal tiara and with her head surrounded by a radiance, she holds the papal keys in her right hand while placing her left on a model of the church. Justice (one of the four "cardinal virtues"), who regulates the actions of the citizen, sits partly behind her, holding in her right hand a pair of scales, the symbol of her impartiality, and supporting in her lap with her left hand the fasces (a scourge and an ax), the symbol of her authority. Seen together, the two virtues may be taken to signify the good governance of the city by Pope Clement X.

Maratti, the leading exponent of High Baroque Classicism, was the most successful Roman painter of the second half of the seventeenth century.

34 GIOVANNI BATTISTA PIAZZETTA
Italian, 1683–1754
A Boy Holding a Pear
(*Giacomo Piazzetta?*)

Black and white chalk on blue-gray
paper (faded light brown), made up
of two pieces joined together
39.2 x 30.9 cm (15⁷⁄₁₆ x 12³⁄₁₆ in.)
Cat. II, no. 33; 86.GB.677

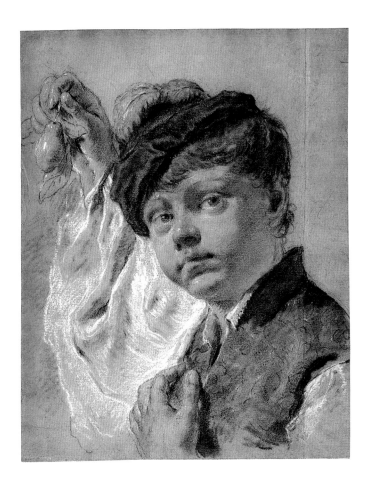

The drawing belongs to a series known as *Teste di carattere* (Character heads), which
together constitute Piazzetta's greatest contribution as a draftsman. The youth, who is
finely dressed in a brocaded vest, full-sleeved shirt, and feathered cap, holds up a pear
and gazes meaningfully at the spectator. This same boy, recognizable from his good-
natured demeanor, who appears in a number of Piazzetta's other works, has been
identified as the artist's son Giacomo. The drawing may be compared in theme as
well as in the gesture of the sitter's right hand to a sheet in the Pierpont Morgan
Library, New York, showing a woman proffering up a pear, and to a painting in the
Wadsworth Atheneum, Hartford, with the same boy, also with a pear but represented
in profile. It has been suggested in connection with the New York drawing that the
woman may have been intended to personify the Sense of Taste.

Of the same scale as this example, or sometimes larger, the drawings in the series of
Teste are usually done in black chalk or charcoal, heightened with white chalk, on blue-
gray or buff-colored paper. Piazzetta handled these materials with great flair, conveying
a haunting sense of lifelikeness in the figures. The chalk was applied with varying
degrees of pressure, the lightly shaded areas of midtone suggesting diffused light and
the more heavily drawn passages rich, velvety shadows or darks. The forms were then
further enlivened by white chalk highlights—in this example in the lace collar and
linen sleeves, in the pear, and on the tip of the boy's nose.

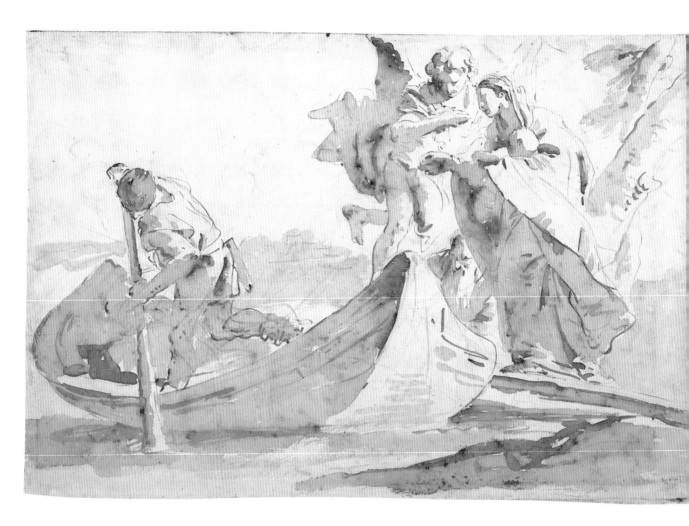

35 GIOVANNI BATTISTA TIEPOLO

Italian, 1696–1770

Flight into Egypt

Pen and brown ink with brown wash, over black chalk
30.4 x 45.3 cm (12 x 17¹³⁄₁₆ in.)
Cat. I, no. 48; 85.GG.409

The Holy Family boarding a ferry during their flight into Egypt is not as common a subject in Christian iconography as the scene of their resting from their travels, though the ingredients were standard enough—a ferryboat in the charge of a boatman, and the Holy Family stepping on board with the assistance of an angel or angels. Tiepolo has interpreted the scene with great brio as well as with a Venetian's nautical expertise. He has chosen a flat-bottomed vessel not dissimilar in type to those that still ply the waters of his native city. A sense of urgency is conveyed by the energetically applied washes and by the dramatic action of the figures—the boatman about to push off from the bank and the Virgin hurrying up the gangplank clutching the Christ Child, with Joseph fast behind, glimpsed head and shoulders just above the stern.

The drawing has been dated 1725–35. The informality of Tiepolo's interpretation of his subject is markedly different from the noble grandeur of Michelangelo's measured invention of the more common scene of the Holy Family's rest on its journey, drawn some two hundred years earlier (see no. 5). Indeed, the contrast between the two images demonstrates the very great changes in Italian art that occurred over two centuries.

Tiepolo, whose work was once described as "all fire and spirit," was without question the greatest Italian painter of the eighteenth century; he was also its greatest draftsman as well as one of its finest engravers. His rich, colorful, and inventive style marks the culmination of the decorative tradition in Italian art and embodies the splendors of Venice in the period of its greatest glory.

36 GIOVANNI BATTISTA TIEPOLO
Italian, 1696–1770
View of a Villa

Pen and brown ink and brown wash
15.3 x 26.1 cm (6 x 10¼ in.)
Cat. I, no. 49; 85.GA.297

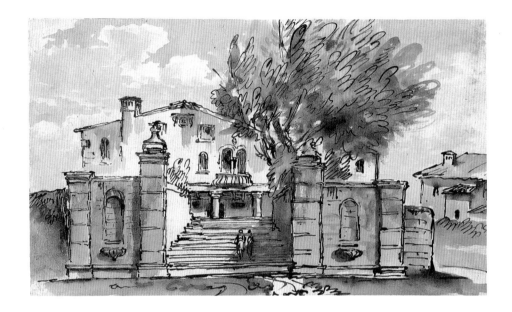

Tiepolo was a gifted landscape draftsman, though his output of such drawings is tiny compared with the large number of his surviving figure studies (see no. 35). Why Tiepolo drew landscapes is not entirely clear, though they were probably done for their own sake, possibly for his diversion on summer visits to the countryside. The rapid pen work together with the dark, fluid washes evoke the bright sunlight and open spaces of the Veneto, the mostly flat terrain in the environs of Venice, dotted with noble villas, houses, and farms.

In this study, the viewer's attention is caught by the stairway and by the fine stonework of the outer wall. The eye follows the two visitors ascending the steps toward the sunlit front of the villa, with its colonnaded portico and pair of round-headed windows giving onto a balcony. The drawing has been dated about 1757–59; it is associated with similar sketches made when Tiepolo was working at the Villa Valmarana, Vicenza (1757), and in Udine (1759).

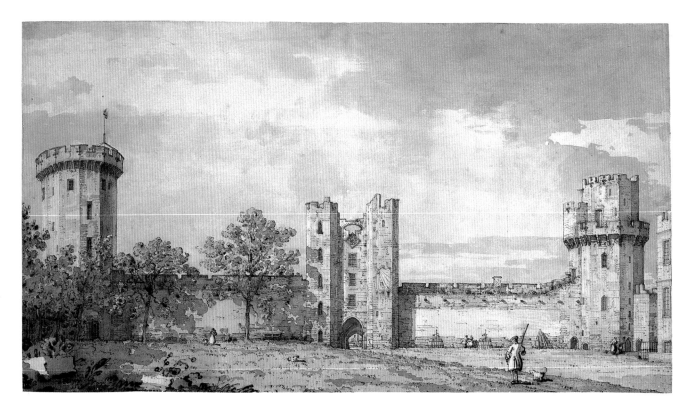

37 CANALETTO
(Giovanni Antonio Canal)
Italian, 1697–1768
*Warwick Castle: The East Front
from the Courtyard*

Pen and brown ink with gray wash
over black chalk
31.7 x 57 cm (12½ x 22⁷⁄₁₆ in.)
Cat. II, no. 9; 86.GG.727

On his visit to Warwick Castle in 1835, the nineteenth-century German art historian
Dr. Gustav Waagen briefly touched on the "beauties and glories of this feudal pile, to
which it would assuredly be difficult to find a rival, at all events in the same well-kept
state of preservation."

The castle stands on the south side of the town overlooking the river Avon.
Although a fortress of some kind was erected on the site in about A.D. 915, the present
exterior (which is the same as in Canaletto's day) dates from the fourteenth century.
The view here, almost certainly drawn on the spot, is of the east front from the inner
court, with the clock tower at the center. It was used as the basis for a painting by the
artist in the City of Birmingham Museum and Art Gallery. A view drawn from the
other side of the same wing is in the Robert Lehman Collection of the Metropolitan
Museum of Art, New York.

Canaletto, a Venetian view painter, visited England in 1746, where he achieved
success in painting views of London and of the country seats of the nobility, such
as Warwick Castle. His work brings a sense of atmosphere as a changeable presence
in what might otherwise be merely a topographical record. He often used a *camera
obscura,* a boxlike device that projects the image of the subject onto a sheet of paper,
thereby allowing the outlines to be traced. He had, moreover, an extraordinary eye for
architectural detail, while his often minuscule figures are credibly, though prosaically,
engaged in everyday activities. As this drawing shows, Canaletto adjusted well to the
representation of English scenes.

38 FRANCESCO GUARDI
Italian, 1712–1793
A Theatrical Performance

Pen and brown ink with brown wash,
over black chalk
27.4 x 38.4 cm (10¹³⁄₁₆ x 15⅛ in.)
Cat. II, no. 19; 89.GG.51

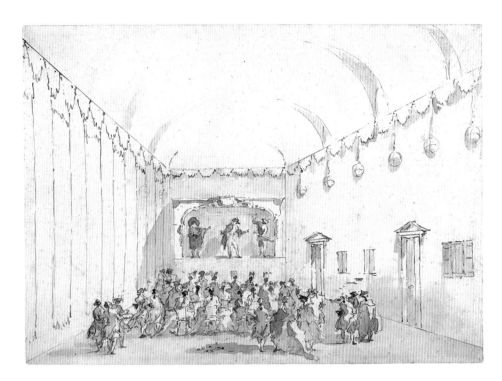

The subject is a theatrical performance, apparently in the presence of a Russian noble couple, christened by the Venetians the "conti del Nord" (evidently to avoid the inconvenience of pronouncing their names in Russian). Grand Duke Paul Petrovitch (the later Czar Paul I) and his wife, Maria Fedorovna, were the guests of the Venetian republic January 18–25, 1782. Here the couple are seen enjoying a performance of the commedia dell'arte staged on their behalf on January 21. The visit was considered of such great moment that Guardi also recorded some of the other entertainments arranged for them, such as a *Concert* (Canterbury, Royal Museum) and a *Banquet* (Saint Petersburg, State Hermitage Museum).

Like his fellow Venetian Canaletto (see no. 37), Guardi was mostly a painter of views of his native Venice, though in his lifetime he did not receive the acclaim of his more illustrious contemporary. Compared with Canaletto's work, Guardi's more vibrantly painted scenes, interiors as well as exteriors, with their much greater freedom of brushwork, suggest instead a more bustling city. They convey the energy of contemporary life, the sense of movement of the crowd, and the excitement of the public spectacle. This same sense of energy is conveyed equally in his drawings.

39 GIOVANNI BATTISTA PIRANESI

Italian, 1720–1778

An Ancient Port

Red and black chalk and brown and reddish wash, squared
38.5 x 52.8 cm (15⅛ x 20¹³⁄₁₆ in.)
Cat. II, no. 34; 88.GB.18

The eighteenth-century English collector, connoisseur, and man of letters Horace Walpole wrote of one of Piranesi's compositions, close to this in type: "He piles palaces on bridges and temples on palaces and scales Heaven with mountains of edifices." This drawing is a study in the same direction, but to a smaller scale, for one of the prints in the series *Prima parte di architetture e prospettive,* published in Rome in 1743. The corresponding print is the *Parte di ampio magnifico porto,* which, according to the artist's lengthy inscription beneath it, was "for the use of the ancient Romans, where can be seen the interior of a great commercial piazza superabundantly decorated with rostral columns that denote the most worthy maritime victories, etc." The miscellaneous engraved architectural compositions that make up the *Prima parte* gave expression to Piranesi's personal and highly fanciful vision of antiquity, comprising measureless heaps of marble set within vast spaces of baffling complexity.

Piranesi first drew the main outlines in chalk, then liberally added brown and red wash for shading and for some of the details. The black chalk grid lines throughout were made to assist the process of transfer of the design to the copperplate (see no. 9); the wash gives a vibrancy to the whole. At least two drawings preceded this finished sketch.

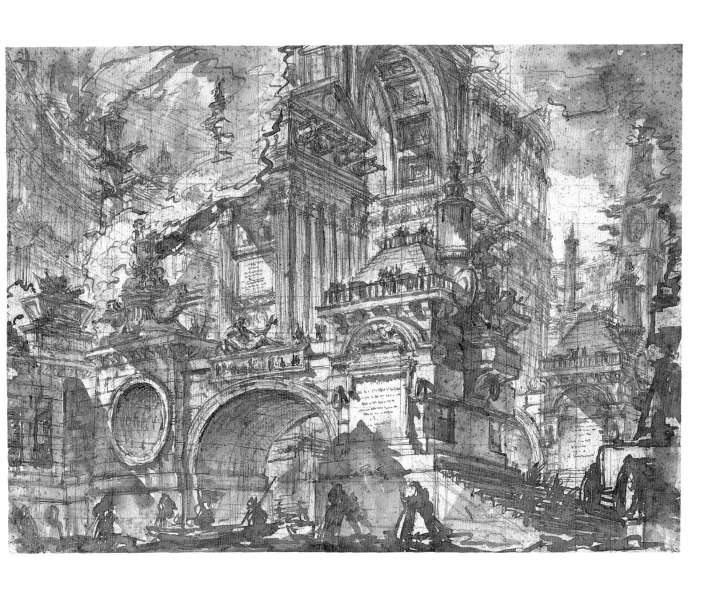

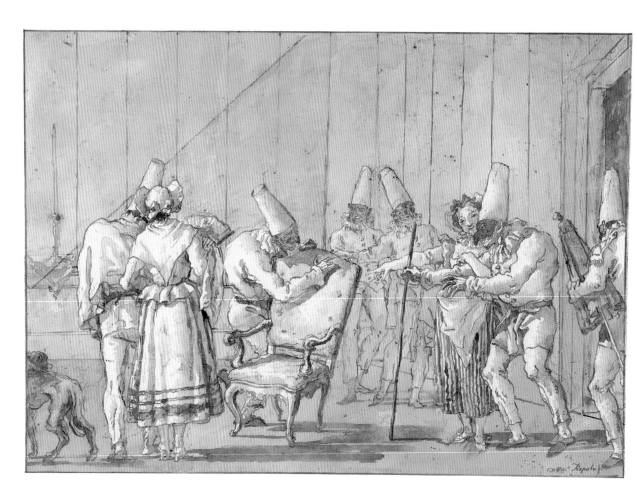

40 GIANDOMENICO
TIEPOLO
Italian, 1727–1804
Punchinello Helped to a Chair

Pen and brown ink and brown wash
over black chalk
35.3 x 47 cm (13¹⁵⁄₁₆ x 18½ in.)
Cat. I, no. 50; 84.GG.10

The drawing belongs to a set of 103 illustrating the life of Punchinello, a character from the Venetian carnival who owes his origin to the commedia dell'arte, a traditional form of popular entertainment in Italy of the sixteenth and seventeenth centuries. "Sly, lazy…up to all sorts of tricks [and] primed with jokes that were often obscene," he was the very antithesis of the noble hero. The compositions from the series range from comedy to tragedy, from trivial incident to events of great moment. In nearly all of them, the tall, hunchbacked figure of Punchinello, clad in white costume, a ruff about his neck, a sugarloaf hat, and black mask with beaky nose, appears amid his companions playing his various, often bizarre, roles. The drawings came from an album that originally bore the title *Divertimento per li ragazzi* (Entertainment for children), made around 1800.

In this example Punchinello staggers in from the outdoors supporting himself with a stick and is helped to a chair. As in other drawings from the series, there is extensive underdrawing in black chalk.

Giandomenico Tiepolo was the eldest son, pupil, and collaborator of his father, Giovanni Battista (see no. 35).

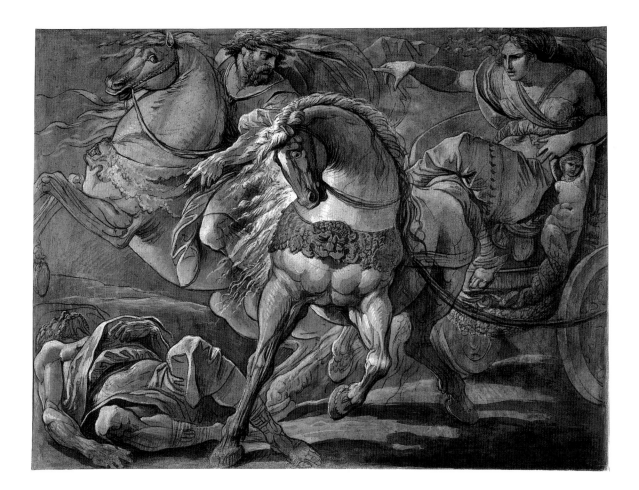

41 GIUSEPPE CADES
Italian, 1750–1799
*Tullia in Her Chariot about to
Ride over the Body of Her Father*

Pen and brown ink, heightened with
white and gray bodycolor, over black
chalk on gray-brown prepared paper
49.5 x 66.4 cm (19½ x 26³⁄₁₆ in.)
95.GA.25

The Roman historian Livy tells us that Tullia was the daughter of Servius Tullius, a legendary king of ancient Rome; she persuaded Tarquinius Superbus to have her father murdered so that he might become king and she queen. Livy describes how, following Servius's assassination in the streets of Rome, Tarquinius had tried to persuade Tullia to avoid the crowds surrounding the body. But she instructed her driver "to take her to the Esquiline Hill; when the man gave a start of terror, and pulling up the reins pointed out to his mistress the prostrate form of the murdered Servius. Horrible and inhuman was the crime that is said to have ensued... for there, crazed by the avenging-spirits, Tullia drove her carriage over her father's corpse, and, herself contaminated and defiled, carried away on her vehicle some of her murdered father's blood."

So far as it goes, the drawing accurately reproduces Livy's account, the artist deliberately focusing on the horror of the event to which Tullia, with her commanding gesture and relentless look, alone remains impervious; even her horses shy away from the deed she is about to perform. Especially characteristic of Cades's draftsmanship is the calligraphic pen work and decorative, formal rhythms of the design—particularly well contrived in the interplay of hoofs and feet in the lower center.

By the 1770s, Cades was regarded as one of the best history painters in Rome. He was associated with the colony of avant-garde foreign artists, mostly British and Scandinavian, who developed an expressive, proto-Romantic vision of classical antiquity that tended to favor grand, often violent, interpretations of ancient mythological themes from Homer, Norse mythology, or Macpherson's *Ossian*.

42 MARTIN SCHONGAUER
German, 1450/53–1491
Studies of Peonies

Bodycolor and watercolor
25.7 x 33 cm (10⅛ x 13 in.)
Cat. III, no. 72; 92.GC.80

During the late fifteenth century, people began to perceive the natural world in a radically new way. Rather than accepting ancient wisdom on the subject, they studied and recorded nature firsthand. South of the Alps, Leonardo da Vinci was the major pioneer of this new attitude, while its principal Northern proponents included Albrecht Dürer and the greatest German painter of the previous generation, Martin Schongauer.

Schongauer is the author of this large watercolor showing three nearly life-sized studies of peony flowers (*Paeonia officinalis* L.) unfolding organically across the page. At the upper left is an open blossom seen from its underside; the artist has carefully rendered the transition from foliage to calyx, sepals, and finally petals. Below this is a tightly closed bud, and, at the right, a fully opened flower, with delicately drawn stamens and pistils. The artist has applied the water-soluble color relatively loosely, making visible the liquidity of the paint and the individual brushstrokes. The free manner of painting and the wind-tossed appearance of the petals and foliage evoke the characteristic lushness of the peony. It is surprising to find such apparent ease and magisterial assurance of execution in one of the earliest surviving Northern European plant studies drawn from life.

Schongauer used it as the basis for some of the peonies in the background of his most important painting, *The Madonna of the Rose Garden,* 1473 (Church of Saint-Martin, Colmar, France). Also attesting to its early date is the paper's watermark, a gothic *p*, that appears on documents dating to the early 1470s. It is highly likely that Albrecht Dürer either owned or knew this drawing, for a closely similar configuration of peonies appears in his watercolor *The Madonna with a Multitude of Animals,* around 1503 (Vienna, Graphische Sammlung Albertina).

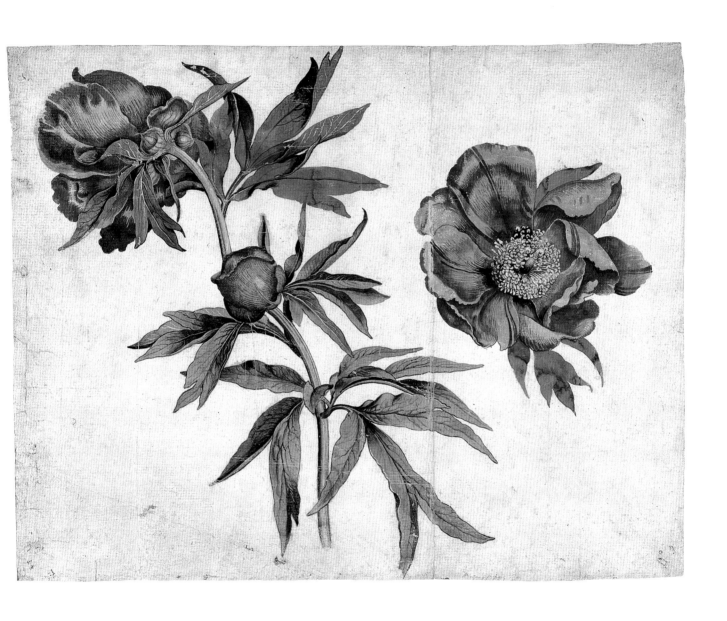

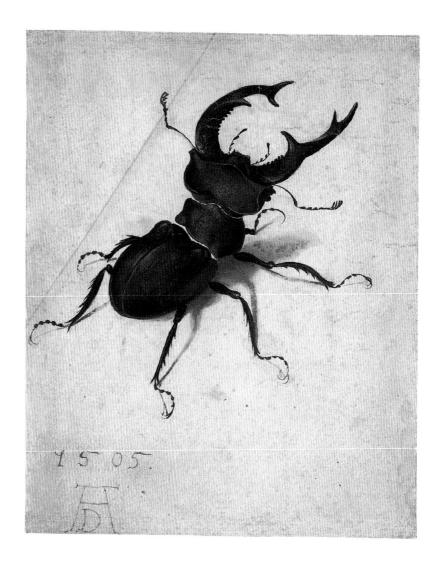

43 ALBRECHT DÜRER
German, 1471–1528
Stag Beetle

Watercolor and bodycolor; top left
corner added; tip of left antenna
painted in by a later hand
14.2 x 11.4 cm (5⁹⁄₁₆ x 4½ in.)
Cat. I, no. 129; 83.GC.214

In this drawing Dürer monumentalizes a humble stag beetle (*Lucanus cervus* L.).
Singling out an insect as the focal point of a work of art was unprecedented in 1505
when Dürer made this drawing. The belief that insects were the lowest of creatures
eroded only as their scientific study developed during the sixteenth century.

Dürer strives to create the illusion of the living animal creeping up the page. He
positions it diagonally on the sheet so that the eye moves up from its abdomen to its
raised head and open mandibles, and he carefully articulates the shadows to give a
sense of the legs raising the body off the ground.

For all of its prescient evocation of the modern scientific attitude, the *Stag Beetle*
is also suffused with Dürer's pious empathy with the creatures of the natural world.
The pronounced serrations on the legs and the spiky mandibles suggest its kinship
to imaginary beasts encountered in late Gothic depictions of hell or the temptation
of Saint Anthony. The *Stag Beetle* exerted a hold on artists for several generations.
Together with his *Hare* (Vienna, Graphische Sammlung Albertina), it was Dürer's
most influential and copied nature study.

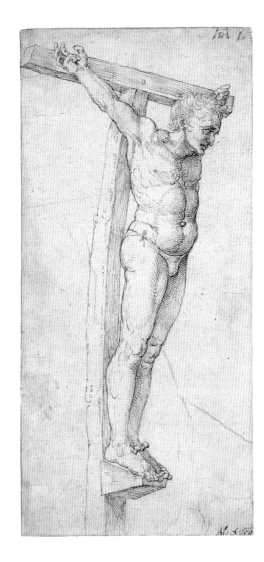

44 ALBRECHT DÜRER

German, 1471–1528

Study of the Good Thief

Pen and brown ink
26.8 x 12.6 cm (10⁹/₁₆ x 5 in.)
Cat. I, no. 130; 83.GA.360

Dürer was the first Northern Renaissance artist to master and advance the classically based articulation of the human form according to rational notions of proportion and anatomy. His efforts culminated in his famous engraving *Adam and Eve,* 1504, and are also evident in the present drawing, which dates to the same period. It depicts the Good Thief, who accepted Christ's deity as he was being crucified with Jesus.

Because of his beatific character, the Good Thief was often shown in a less contorted pose than the Bad Thief. Here, his anatomy exhibits a classical sense of unity and integration; all of the parts interrelate to produce the effect of the body sagging, its weight bending the cross forward. Dürer carefully delineates bone and sinew, from strained arms, to the skin stretched tightly over the rib cage, to the tautly braced legs. He has repeatedly gone over the chest, stomach, and legs with hook-shaped hatching, which heightens one's awareness of the musculature beneath the skin. The drawing also includes a difficult perspectival effect whereby the thief's left hand is convincingly foreshortened above his head. According to the classical theory of art, physical movement and facial expression should work in tandem toward the ultimate goal of conveying the motions of the soul. This is apparent in the thief's profound and soulful gaze at Christ, with Dürer's shadowing of the face enhancing its depth of feeling.

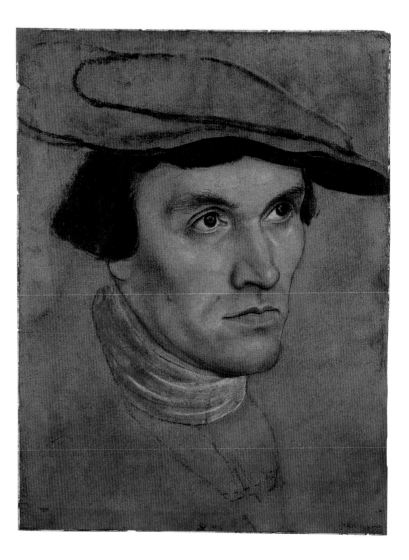

45 LUCAS CRANACH THE ELDER
German, 1472–1553
Portrait of a Man

Oil on paper
26.2 x 19.9 cm (10⁵⁄₁₆ x 7⅞ in.)
Cat. III, no. 64; 92.GG.91

From 1504 until his death, Cranach served at the court of Saxony in Wittenberg, where he devoted much of his artistic effort to portraits. This unidentified sitter's portrait was made with brush and oil paint on paper, a technique uncommon in Northern European drawings of the early sixteenth century. Cranach rubbed the paper with oil to produce a brownish ground and then sketched in the outlines of the head. He worked up the face meticulously, going over various parts, such as the eyebrows, lashes, and outer facial contours, in pen and black ink. The contrast between the luminous face with its gleaming white highlights and the brown ground makes the sitter seem to move forward out of depth. The sense of living presence created by this effect is further enhanced by the young man's large and intelligent eyes. The intensity of expression plus the jewel-like refinement of its surfaces combine to make this one of Cranach's finest surviving portrait drawings.

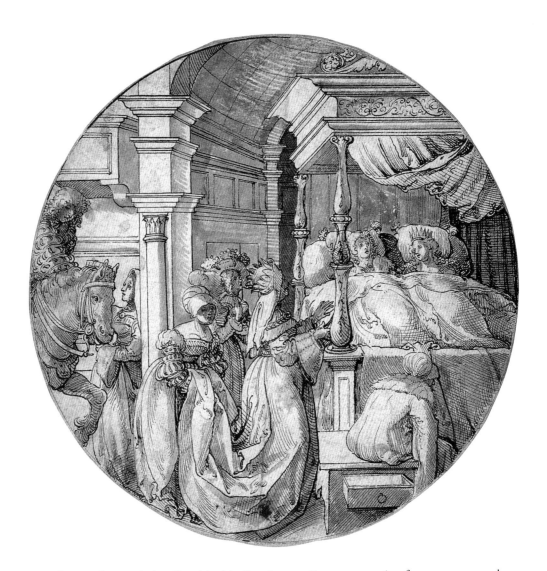

46 JÖRG BREU THE ELDER
German, circa 1475/76–1537
Bridal Scene

Pen and black ink, brown and
orange wash
Diam. 19.8 cm (7¹³⁄₁₆ in.)
Cat. II, no. 121; 89.GG.17

The art of stained glass flourished in Renaissance Germany, ranging from monumental church windows to small-scale panels in secular buildings. All the major German and Swiss artists of the Renaissance produced drawings for stained glass, which served as models for the "glass painter," the master craftsman who translated them into leaded glass.

One of early sixteenth-century Germany's most engaging designers of stained glass was Jörg Breu the Elder of Augsburg. He particularly excelled at making designs of secular subjects, such as the present example, which illustrates Tale 20 from the fourteenth-century book *Gesta Romanorum* (The deeds of the Romans). The story tells of a boy who, cursed at birth by the emperor, eventually became his son-in-law. The drawing combines two episodes (moving left to right): first, the youth's arrival at court, and, second, his somewhat uncomfortable presence with the emperor's daughter in the marriage bed, watched by the empress and her ladies-in-waiting.

The extensive use of yellow wash, the lavish costumes, and the grand architectural setting with the ornate Renaissance bed make this a splendid drawing. Breu masterfully combines the circular format of the drawing with the articulation of the architectural elements to produce the effect of looking up into a domed space. His conversance with classically inspired architecture and ornament suggests that he may have made this drawing after a trip to Italy in 1514/15.

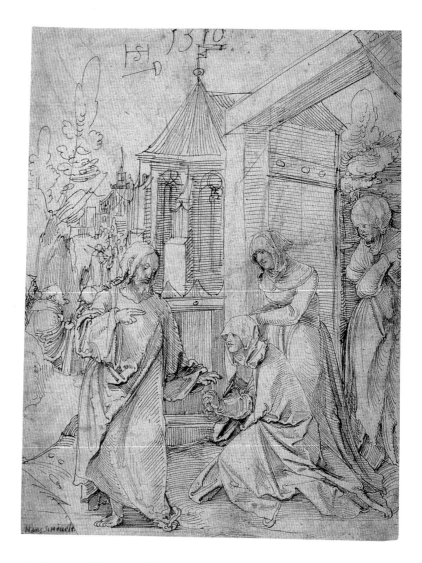

47 HANS SCHÄUFELEIN
German, 1480/85–1539
Christ Taking Leave of His Mother

Pen and dark-brown ink over traces
of black chalk
27.5 x 21.2 cm (10¹³⁄₁₆ x 8⁵⁄₁₆ in.)
Cat. I, no. 134; 85.GA.438

A painter and designer of woodcut illustrations, Schäufelein worked in Dürer's atelier in Nuremberg from 1503/4 to 1516/17. He often accompanied his initials by a drawing of a *Schäufelein* (little shovel—the meaning of his name) as in this drawing, signed and dated 1510.

The New Testament does not include the incident of Christ taking leave of his mother; its literary sources are found in late medieval devotional writings. As the story goes, the Virgin, accompanied by Mary Magdalene and Martha, begged her son not to leave Bethany for Jerusalem, where he would be betrayed and eventually crucified. Replying that he must go in order to save humanity, Christ gave his mother his blessing as he departed, telling her that she would be enthroned with him in heaven.

Schäufelein depicts the moment of benediction, placing the event in front of a rustic wooden city gate. To Christ's right the crowds make their way to Jerusalem for Passover. At the center of the drawing is a feature unusual for this scene: a Gothic church, which may refer to the Virgin Mary. Since the Middle Ages, the church was thought to be the Virgin's physical embodiment on earth. Such symbolism would mean that the image points hopefully beyond the sorrow of the Passion to the founding of the Church.

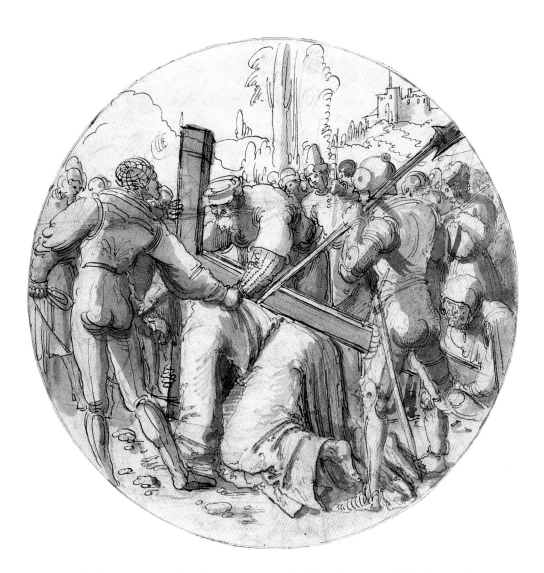

48 ALBRECHT ALTDORFER
German, circa 1482/85–1538
Christ Carrying the Cross

Pen and black ink, gray wash,
and black chalk
Diam. 30.4 cm (11¹⁵⁄₁₆ in.)
Cat. II, no. 113; 86.GG.465

Altdorfer was the leading figure in the so-called Danube school. This designation
refers to a group of artists working near and along the Danube, from Regensburg to
Vienna, whose imagery features alpine landscapes and emotion-charged religious and
mythological subjects. The present drawing is Altdorfer's only surviving design for
a stained-glass window.

Altdorfer often heightened the dramatic impact of a scene by showing it from
an unusual vantage point, as is the case here. The fallen Christ is seen from the rear,
with emphasis placed on his bent left leg, the exposure of the soles of his feet, and his
haggard profile. The violence and energy of the scene are further conveyed by crowding
the figures parallel to the picture plane and by the dynamic, unpredictably varied pen
work. Stylistic comparisons with other works by Altdorfer suggest a dating of around
1515 or perhaps a few years before.

49 NIKLAUS MANUEL DEUTSCH

Swiss, 1484–1530

The Mocking of Christ

Pen and black ink, painted gold, heightened with white bodycolor, on red-brown prepared paper
31.2 x 21.7 cm (12�5/16 x 8⁹/16 in.)
Cat. I, no. 140; 84.GG.663

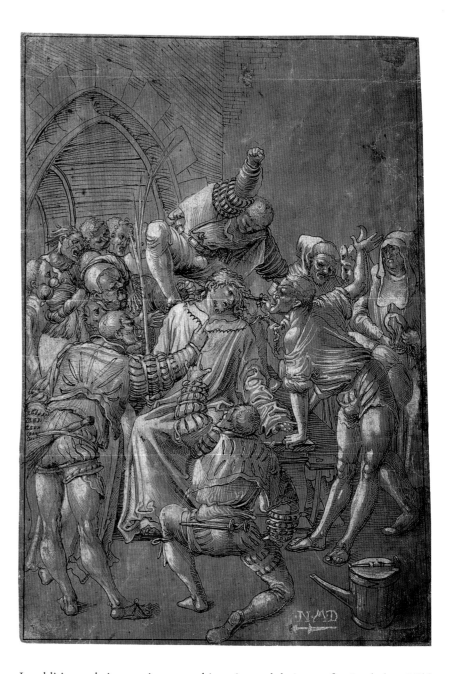

In addition to being a painter, graphic artist, and designer of stained glass, Niklaus Manuel was a poet, mercenary soldier, and active in Bern city government, particularly in furthering the cause of the Reformation. He probably made this carefully crafted drawing of around 1513/14 as a finished work of art. After preparing the paper with a reddish-brown ground, he drew the scene in black ink. The line work is energetic and sharp. He then laid in the lavish white heightening with a brush, touched in Christ's halo with gold pigment, and refined additional details in black ink. Further attesting to the drawing's status as an independent work of art is the framing line, which appears to have been made by the artist himself and is wittily called attention to at the bottom by the soldier's foot that extends outside its bounds.

The vitality of the pen work and the extensive highlighting complement the frenzied violence of the scene. The artist has devised a dynamic radial composition, with Christ's luminous head as the focal point of attacks directed at him from all sides.

50 URS GRAF

Swiss, circa 1485–1527/29

Dancing Peasant Couple

Pen and dark-brown and black ink
20.6 x 14.7 cm (8⅛ x 5¹³⁄₁₆ in.)
Cat. III, no. 66; 92.GA.72

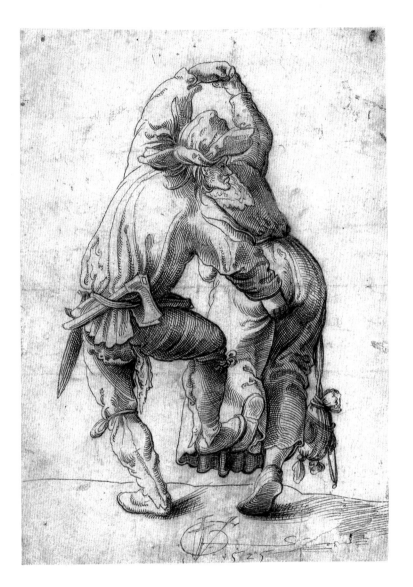

Graf's drawings are notable for their brilliant, eccentric pen work and their focus on violence and sexual innuendo, qualities that seem to bear a relation to his life. He is documented as having hired himself out as a mercenary soldier on various occasions and as having been banished temporarily from his home city of Basel as a result of a brawl.

Graf brought this dark and satiric point of view to a series of nine sheets of unknown purpose (now scattered in various museums), showing differently configured dancing peasant couples. All bear his monogram, *VG* with the *Dolch* (the Swiss dagger), and the date of 1525. The drawing in the Getty Museum depicts an interlocking couple, with the male obscuring his partner's head and pinching her buttock. The dagger and ax he carries heighten the lascivious and violent overtones. This notion of the peasantry—brutal, fertile, and full of vital energy—is bolstered by Graf's swift and incisive pen work.

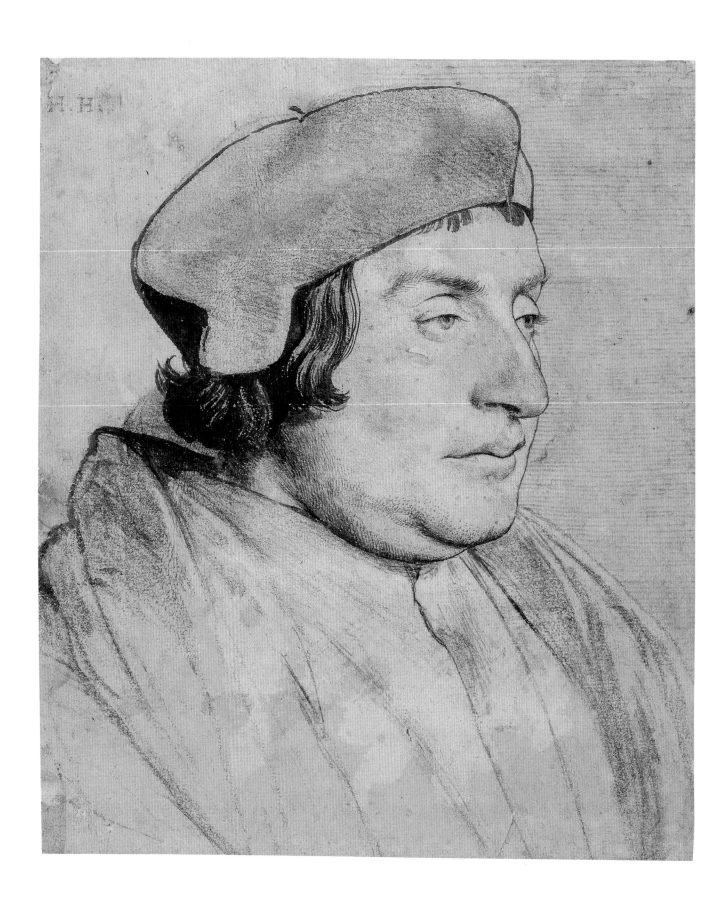

**51 HANS HOLBEIN
THE YOUNGER**
Swiss, 1497–1543
Portrait of a Cleric or Scholar

Black and red chalk, pen and brush
and black ink, on pink prepared paper
21.9 x 18.5 cm (8⅝ x 7¼ in.)
Cat. I, no. 138; 84.GG.93

Holbein moved permanently from Basel to London in 1532, and in 1536 he became court painter to King Henry VIII. When Holbein died in 1543, his many drawings of members of the court seem to have passed into the ownership of Henry VIII and were gathered into the so-called *great booke,* first documented in 1590. The renowned Holbein drawings in the Royal Library, Windsor Castle, are from the great book, and it is possible that the portrait of an unknown sitter in the Getty Museum is as well.

Holbein sketched the figure broadly in black chalk and subsequently added the ink. He drew the outline of the hat with a pen, laid in the hair and collar with a brush, and used a quite fine nib to delineate the contour lines of the face and various facial details, such as the small dots suggesting the stubble of an incipient beard. The face is modeled with the utmost subtlety using light applications of red chalk over the pink ground of the paper. The figure's stasis and detachment coupled with the marvelous precision with which Holbein captures his features enhance the portrait's aura of timelessness and authority.

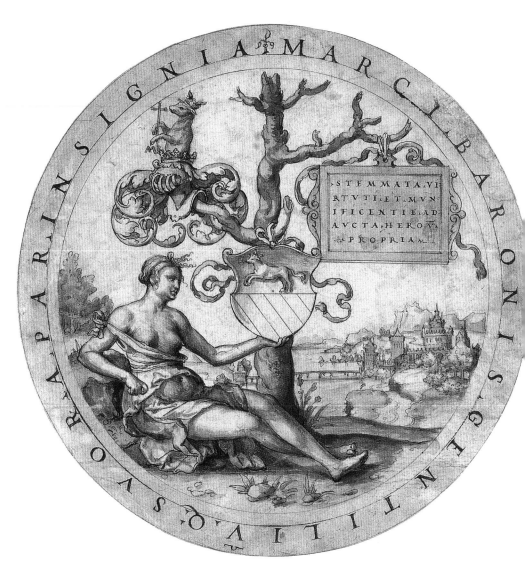

52 GEORG PENCZ

German, circa 1500–1550
*Study for a Stained-Glass
Window with the Coat of Arms
of the Barons von Paar*

Pen and brown ink and gray wash
Diam. 24.7 cm (9¹¹⁄₁₆ in.)
Cat. I, no. 133; 83.GA.193

Of all of Dürer's pupils, Pencz, who appears to have visited Italy twice, strove most
consistently to emulate the art of the Italian Renaissance. This design for a stained-glass
roundel conforms to Italianate norms with respect both to form and to content. The
arms in the drawing are identified by the surrounding inscription as those of Marcus
Belidorus de Casnio (alive in 1170), an ancestor of the von Paar family which
originated in Bergamo, Italy. The inscription hanging from the tree suggests the
continuation of the glory of his descendants, stating: "The family trees of heroes grow
greater through virtue and munificence." This is a humanist sentiment whose classical
basis is underscored by the lettering in ancient Roman inscriptional capitals. Pencz
has emphasized the sculpturally rounded contours of the female figure by modeling
them in carefully modulated tones of gray wash. The principal Northern note in this
configuration is the lively landscape vista at the lower right, with a turreted city
silhouetted against a mountainous backdrop.

53 JOSEPH HEINTZ THE ELDER
Swiss, 1564–1609
The Toilet of Venus

Red and black chalk
21.5 x 15.1 cm (8½ x 5¹⁵⁄₁₆ in.)
Cat. III, no. 67; 91.GB.66

In 1592, Holy Roman Emperor Rudolf II of Prague sent Heintz, his court painter, to Rome to make drawings of antiquities and to acquire works of art for the imperial collections. Heintz was probably still in Rome when he executed this drawing, which is signed and dated 1594. The prominent signature and the high degree of finish indicate that the drawing was probably made as a work of art in its own right.

Under a parted curtain in her boudoir, Venus combs her long tresses. A highly unusual feature is the female cherub holding the mirror, who replaces Cupid, Venus's normal attendant. The ornamental gracefulness of the figures and the velvety surfaces created by the subtle modeling in chalk are typical of Heintz's manner. He was particularly attracted to the work of the sixteenth-century Italian masters Correggio and Parmigianino, gleaning elements from their styles as well as from other artists to produce softly sensuous, often erotic, imagery. The blending of red and black chalk, which had an extensive prior history in Italian draftsmanship, is used with exceptional mastery by Heintz, both here and in other drawings.

54 ADOLF VON MENZEL
German, 1815–1905
Figure Studies

Carpenter's pencil
37.9 x 26.3 cm (14¹⁵⁄₁₆ x 10⁵⁄₁₆ in.)
Cat. I, no. 132; 84.GB.6

In 1872 Menzel spent several weeks at the vast smelting works in Königshütte, Upper Silesia, making many drawings of the iron-production process. He employed these studies in the execution of his masterpiece, *The Iron Rolling Mill,* 1875 (Berlin, Nationalgalerie), one of the most important nineteenth-century paintings of an industrial subject.

This study for *The Iron Rolling Mill* is clearly related to the figures in the center of the composition who are moving a glowing piece of iron toward the rollers, while their co-workers are shown eating and washing, indicating a change of shift. Menzel's almost photographic ability to record the interaction of light and form is fully in evidence in this drawing. The shifting, fractured quality of the shadows plus the roughness of the carpenter's pencil enhance the sense of the worker's performing heavy, physical labor. He is a monumental figure and as such embodies Menzel's view of the worker as the heroic prime mover in the advancement and progress of society.

55 FRANS CRABBE VAN ESPLEGHEM
Flemish, circa 1480–1552
Esther before Ahasuerus

Pen and dark-brown ink,
with touches of gray wash,
over black chalk, incised for transfer
23.7 x 19.4 cm (9⁵⁄₁₆ x 7⁷⁄₈ in.)
Cat. III, no. 80; 90.GA.4

Crabbe, active in the city of Mechelen, northeast of Brussels, was among the most
accomplished and innovative Netherlandish printmakers of the early sixteenth century.
He successfully explored copperplate etching, then a nascent medium. His only known
surviving drawing, the present example, indicates that Crabbe made precise studies for
his etchings. The drawing corresponds almost exactly to the scale of his etching *Esther
before Ahasuerus,* which dates around 1525. Crabbe appears to have traced the drawing
directly onto the plate, as evidenced by the incising lines throughout the sheet. The
drawing also shows Crabbe to be a fluent and original draftsman, whose style combines
Netherlandish restraint of gesture and expression and an interest in effects of light and
shadow with the dashing, delicate pen work more typical of German artists of the period.

The story is from the Old Testament. Esther, a Jewish beauty, married King
Ahasuerus of Persia but concealed her religion from him. When a death edict was
placed on the Jews, she risked her life by petitioning her husband for the salvation of
her people. The drawing depicts the moment when the king places his golden scepter
on Esther's head, bidding her to speak.

Crabbe's portrayal evokes the typological significance that since the Middle Ages
had been associated with this story as a prefiguration of the Virgin's intercession with
God on behalf of the faithful. The carefully nuanced hatching throughout the drawing
establishes a wide range of tonal values, which the artist closely followed in the etching.
These are particularly important in the architectural passages in the etching, in which
the tones are translated into pools of light and shadow that lend lofty eloquence to the
events taking place below.

56 HANS BOL

Flemish, 1534–1593

Landscape with the Story of
Venus and Adonis

Bodycolor heightened with gold
on vellum (image) and wood (frame)
20.6 x 25.8 cm (8⅛ x 10³⁄₁₆ in.)
Cat. III, no. 77; 92.GG.28

Highly regarded as a draftsman and designer of prints, Bol was most revered as a
miniaturist. An offshoot of manuscript illumination, miniature painting became
widespread at the end of the sixteenth century, when artists began to produce such
objects for collectors, who appreciated their preciosity and miraculously tiny scale.

This is one of Bol's finest and most unusual miniatures. It consists of two separate
parts: the central image on vellum mounted on wood, signed and dated *HBol/1589,*
and a frame painted on wood prepared with gesso and dated *1589.* This latter element
cleverly combines the characteristics of a three-dimensional picture frame with those of
the two-dimensional illusionistic borders encountered in earlier manuscript illumination.

Bol's miniature depicts the life and death of Adonis. In the central panel, Venus
and Adonis embrace before he leaves on the fatal hunt, shown in the distance, in which
he is killed by a boar. The ovals within the frame show subsidiary incidents: clockwise
from the left, Myrrha, Adonis's mother, committing incest with her father, who thereby
fathered Adonis; Myrrha, having been punished by being turned into the myrrh tree,
gives birth to her son; Venus is struck with love for Adonis; and blood springing from
the dead Adonis turns into the anemone flower.

The story is from Ovid's *Metamorphoses.* This classical text profoundly influenced
the sixteenth-century view of nature, characterizing it as being in a constant state of
flux and transformation, due to the restless, often reckless, amours of the gods.
References to transformation occur throughout Bol's miniature, including the
decorative frame, in which the myriad elements are densely interwoven, yet without
any repetition.

57 HENDRICK GOLTZIUS
Dutch, 1558–1617
*Venus and Mars Surprised
by Vulcan*

Pen and brown ink, brown wash,
over black chalk, heightened with
white bodycolor
41.6 x 31.3 cm (16⅜ x 12⁵⁄₁₆ in.)
Cat. I, no. 107; 84.GG.810

In 1583, Goltzius was introduced to the drawings of his contemporary Bartholomäus Spranger. Court painter to Holy Roman Emperor Rudolf II of Prague, Spranger was a figure painter renowned for his mythological compositions featuring deliberately complex, erotic poses. Goltzius had an extraordinary talent for mastering the styles of other artists. So taken by Spranger was he that he not only produced virtuoso engravings after Spranger's drawings but also devised compositions of his own invention based on Spranger's manner.

The present drawing is a full-scale model for Goltzius's largest and most complex engraving in the Spranger style, published in 1585. The composition, entirely Goltzius's own, is based on the story recounted in both Homer's *Odyssey* and Ovid's *Metamorphoses*. Apollo spotted the illicit lovers Mars and Venus and informed Venus's husband, Vulcan, who forged a net in which to entrap them, as seen in the right background of the drawing. In the foreground, Vulcan has ensnared the couple and called in Hercules, Apollo, Jupiter, Neptune, and other Olympians to ridicule them.

This virtuosic orchestration of two registers of nudes, in a composition of extravagant complexity made to appear effortless, helped secure Goltzius's reputation as one of the premier Northern European figural artists of his day.

58 PETER PAUL RUBENS
Flemish, 1577–1640
Anatomical Studies

Pen and brown ink
28 x 18.7 cm (11 x 7⅜ in.)
Cat. II, no. 85; 88.GA.86

Executed in luminous light-brown ink, the present example is one in a group of
drawings by Rubens portraying full or partial views of écorchés—anatomical figures
that show the muscles with the skin removed. The principal figure demonstrates the
musculature of the back, buttocks, and legs seen from a vantage point at the bottom
right, with subsidiary views of the same figure and a detail of the left arm seen from the
top left. The web of diagonals and orthogonals created by the figures and enhanced by
their lunging poses displays a complex and dynamic grasp of the human form. Shortly
after Rubens's death, the engraver Paulus Pontius reproduced several of Rubens's
anatomical studies, including that in the Getty Museum, in a series of prints after the
master's drawings.

Anatomical Studies encapsulates the intensive and synthesizing study of the human
form that Rubens undertook during his youthful Italian sojourn (1600–1608). Calling
to mind his drawings after antique sculpture, the sheet also demonstrates a grasp of the
body's muscular structure that was probably informed by the greatest anatomy book of
the Renaissance, Andrea Vesalius's *De humani corporis fabrica,* 1543. One also notes
the impact of Michelangelo, both in the extensive, delicate hatching articulating the
musculature and in the surging, heroically proportioned forms.

59 PETER PAUL RUBENS
Flemish, 1577–1640
A Man Threshing beside a Wagon, Farm Buildings Behind

Colored chalk and touches of pen and brown ink on pale-gray paper
25.5 x 41.5 cm (10 x 16⁵⁄₁₆ in.)
Cat. I, no. 92; 84.GG.693

This rural scene focuses on a rustic wagon shown in sharp perspective from the rear. Although the wagon is stationary, it is charged with vitality. The rear wheels, axle, and splayed side rails thrust outward toward the picture plane, while the front axle, which is out of alignment with the rear, simultaneously draws the eye into space. The dappled sunlight and shadow on and around the vehicle lend it further vigor and expansiveness.

The man threshing beside the wagon heightens its monumentality. Rubens's experimentation with different positions of the flail increases its effect of upward motion. The flail dynamically connects the motif of the thresher with that of the wagon by creating a visual arch carried through the wagon shaft extending toward the flail. The varied use of materials, from the red and black chalk and delicate pastels to the rough brown ink with which Rubens picks out the iron bands and nails on the outside of the rear wagon wheels, increases the verisimilitude and immediacy of the scene.

The wagon recurs in several of Rubens's paintings—*The Prodigal Son* (Antwerp, Koninklijk Museum voor Schone Kunsten), *Landscape with a Country Wagon* (Saint Petersburg, State Hermitage Museum), and *Winter* (Windsor Castle, Collection of Her Majesty the Queen). The drawing is generally thought to have been made around 1615–17.

60 PIETER JANSZ. SAENREDAM

Dutch, 1597–1665

The Choir and North Ambulatory of the Church of Saint Bavo, Haarlem

Red chalk, graphite, pen and brown ink, and watercolor, the outlines indented for transfer (recto); rubbed with black chalk for transfer (verso)
37.7 x 39.3 cm (14¹³⁄₁₆ x 15⁷⁄₁₆ in.)
Cat. II, no. 105; 88.GC.131

The subtle art of the architectural painter Pieter Saenredam records and immortalizes the historic edifices of his native Holland, primarily its churches. He depicted some churches, such as Saint Bavo in Haarlem, repeatedly and from various vantage points. Among the most symmetrical and balanced of his depictions of Saint Bavo's interior, this large, nearly square drawing takes in a deep vista, stretching from the Brewers' Chapel on the south side of the church across the side aisles and nave and terminating in the Christmas Chapel, directly opposite. Known as a construction drawing, this is a one-point perspective rendering made in the studio, based on a study done on the spot in October 1634 (Haarlem, Municipal Archives).

The Museum's drawing exemplifies Saenredam's meticulous process of creating a finely tuned, harmonic spatial complex, whose sense of balance is heightened by calm sunlight suffusing the whole. He appears to have begun by making a series of vertical and horizontal ruled graphite lines that, among other things, regularize the relationships among various architectural elements and establish a central vertical axis on which he placed the vanishing point, clearly visible between the figures at the bottom. He then elaborately finished the sheet in pen and ink, wash, and watercolor.

Saenredam inscribed the right-hand pier, recounting that he made the drawing in November 1634 and finished the painting after the drawing on October 15, 1635. The painting based upon the Museum's drawing, which contains still further alterations, is in the Muzeum Narodowe, Warsaw.

61 ANTHONY VAN DYCK
Flemish, 1599–1641
The Entombment

Black chalk, pen and brown ink,
brown and reddish wash, red and
blue chalk, and white bodycolor
heightening
25.4 x 21.8 cm (10 x 8⅝ in.)
Cat. I, no. 86; 85.GG.97

After some preliminary sketching in black chalk, Van Dyck drew the figures in pen and ink and then went back over much of the composition with gestural strokes of dark-brown wash. He also drew the framing line around the composition. The extremely fine pen lines left visible on Christ's torso lend it poignant beauty, while the tenebrous wash creates a sense of dramatic motion around the dead Christ. The figure of Saint John the Evangelist in the middle of the composition, whose gracefully turning form links the pairs of figures flanking Christ, is reminiscent of types employed by Leonardo or Raphael. As a whole, the composition is inspired by Titian's painting *The Entombment* (Paris, Musée du Louvre), which Van Dyck would have known from a copy by Rubens. Van Dyck, however, exchanges Titian's sweeping horizontal composition for a more tightly integrated, vertical format, which allows him to give greater monumental prominence to the standing, shrouded Virgin, who holds the arm of her dead son. This drawing is thought to have been made in 1617–18, probably in preparation for a painting that was planned and abandoned or else does not survive.

62 REMBRANDT HARMENSZ. VAN RIJN
Dutch, 1606–1669
Nude Woman with a Snake

Red chalk with white bodycolor heightening
24.7 x 13.7 cm (9¹¹/₁₆ x 5⁷/₁₆ in.)
Cat. I, no. 114; 81.GB.27

Among the most powerful and enigmatic of any of Rembrandt's drawings of single figures, this is his only surviving red-chalk drawing of a female nude. Based on a live model, the woman does not possess a fixed identity, but rather incorporates both real and imaginary elements.

The snake and headdress together with the squeezing of the breast suggest that Rembrandt envisaged the model as a historical or mythological character, but the identity of this character is difficult to decipher. While the most widely accepted interpretation has been that of Cleopatra, it has recently been suggested that the figure incorporates aspects of Eve: Rembrandt used the drawing as the basis for the body of Eve in his etching *Adam and Eve,* 1638.

The drawing is a prime example of Rembrandt's mastery of the red-chalk medium. He applied the chalk energetically, rendering the model's belly with emphatically horizontal strokes, while imparting taut strength to her legs through vertical shading. He also exploited the chromatic brilliance and luminosity of natural red chalk by applying white bodycolor underneath it, particularly in the model's right arm and torso. The glowing quality of the red chalk with white underneath plus the forceful three-dimensionality of the form create an impression of energy radiating from the woman. High Renaissance artists, such as Andrea del Sarto, had established red chalk as the preferred medium for drawing the nude figure from life. In this vibrant and monumental study, Rembrandt, perhaps self-consciously, demonstrates a level of draftsmanship worthy of the great masters of the past, while he simultaneously pushes his medium in new directions.

63 REMBRANDT
HARMENSZ. VAN RIJN
Dutch, 1606–1669
A Sailing Boat on a Wide Expanse
(*View of the Nieuwe Meer?*)

Pen and brown ink and brown wash
on light-brown tinted paper
8.9 x 18.2 cm (3½ x 7³⁄₁₆ in.)
Cat. I, no. 117; 85.GA.94

Rembrandt here eloquently captures the architecture of the Dutch landscape, with
its flatness and expansive horizontality, punctuated by a lone sailboat. Anchoring the
composition in the left foreground is a mass of bulrushes. A breeze blows toward the
right, animating the rushes, gently tilting the sailboat, and reinforcing the spatial sweep
of the vista that opens out. The eye follows ripples on the water, a spit of land, a house,
and other features into the distance until discernible elements dissolve into a cluster
of suggestive dots on the horizon. Bracketing the deepest segment of the vista are
the rushes and the sailboat. The spatial complexity of the scene is increased by the
combination of deep recession with a heightened effect of lateral expansion. The beauty
of execution and the careful calibration of the composition suggest that this drawing of
about 1650 was made as a finished work of art.

64　PHILIPS KONINCK
Dutch, 1619–1688
River Landscape

Watercolor and bodycolor
13.4 x 20 cm (5⁵⁄₁₆ x 7⁷⁄₈ in.)
95.GA.28

Koninck is best known for his large oil paintings of landscapes, but he also depicted scenes of this type in small-scale watercolors, such as this example of around 1675, which appears to have been made as an independent work of art. An imaginary vista, it is nonetheless inspired by the flat Dutch landscape. Its principal compositional element is the axis leading into space that issues from the wedge of land in the foreground of the image. Rivers, roads, and fields converge inward from both sides, gradually leading the eye into the distance. The composition finds its point of resolution at the farthest end of the river valley.

In contrast to the way in which many seventeenth-century Dutch watercolorists exploited the medium's capacity for brilliant, jewel-like hues, Koninck adopts a soft palette that includes buffs and browns, deep green, gray, and light blue. He also makes extensive use of opaque color, applied thickly and loosely, particularly in the foreground. This palette plus his painterly handling allow him to portray the landscape as an integrated whole, governed by aerial perspective. Accordingly, space progresses seamlessly from the more concrete, textured foreground to the incremental fading of color and clarity in the distance.

65 AELBERT CUYP

Dutch, 1620–1691

View of the Rhine Valley

Black chalk, graphite, and gray wash
13.2 x 23.7 cm (5³/₁₆ x 9⁵/₁₆ in.)
Cat. II, no. 95; 86.GG.673

Cuyp made this unidentified panorama as part of a sketchbook of landscape views
compiled during a visit to Nijmegen and Cleves in 1651–52. He drew the foreground
in textural black chalk, switching to silvery graphite in the background to convey the
effect of aerial perspective. The compression of the landscape into thin strata trailing
unimpeded off both sides of the page, combined with the large area of blank sky, create
a strong sense of lateral expansiveness. Despite this implicit vastness, the view also
seems miniaturized because of the many details rendered on a tiny scale. These include
buildings, boats, figures, and even grazing animals indicated by flecks of chalk on the
field in the middle distance. While Cuyp used several of the landscapes from this
sketchbook in later paintings, he does not appear to have made further use of the
present example.

66 JOSEPH-BENOÎT SUVÉE

Belgian, 1744–1807

The Invention of Drawing

Black and white chalk on brown paper
54.6 x 35.5 cm (21½ x 14 in.)
Cat. II, no. 87; 87.GB.145

Suvée was a successful painter who assumed the position of director of the French
Academy in Rome in 1801 and supervised its relocation to the Villa Medici, where it
remains today. This drawing, made as a gift to the painter Gerard van Spaendonck,

replicates a painting Suvée exhibited in the
Paris Salon of 1791 (Bruges, Groeningemuseum).

It shows the daughter of the sculptor
Butades tracing her lover's profile on a wall of
her father's studio to retain a remembrance of
his appearance after his departure. This story of
the invention of drawing, taken from Pliny the
Elder's *Natural History*, was frequently depicted
by eighteenth-century artists. Suvée shows an
oil lamp throwing the pair's shadows on
the wall. He demonstrates a Neoclassical
archaeological interest in antique costume and
the accoutrements of an ancient pottery studio.
The art of drawing is thus shown as having its
origin in youthful passion and in the silhouette
as the trace of the lover's living presence.

67 VINCENT VAN GOGH
Dutch, 1853–1890
Portrait of Joseph Roulin

Reed and quill pens and brown ink
and black chalk
32 x 24.4 cm (12⅝ x 9⅝ in.)
Cat. I, no. 106; 85.GA.299

As recorded in a letter to his brother Theo, Vincent sent this drawing on August 3, 1888, to the Impressionist painter John Russell. It is one of Vincent's many painted and drawn portraits of Joseph Roulin, the postman who became the artist's devoted friend during his residence in Arles in 1888/89. Although the drawing is based on a painting (Detroit, private collection), it is very different from the painting, due in no small measure to the power and variety of its line work.

It is a deeply sympathetic portrayal. The postman's rugged face is alive with dynamically converging curves and facets, articulated by exploratory hatching and stippling. The only feature that diverges from the emphatic frontality of the figure is the sideward gaze of the widely set eyes surrounded by luminous blank paper. With dark, thick lines rendered by a reed pen, the artist has delineated the cap, beard, and coat. The circularity of the cap is carried through in the coat, with the hatching of its two sides seemingly pulled downward by the large button, which acts as a fulcrum at the base of the lapels. The background is drawn with a quill pen and contains a patchwork of nervous, intersecting lines that create an overall surface tension and reinforce the energy emanating from the sitter. Van Gogh wrote in his letters that he regarded Roulin as a Socratic figure. This comes through clearly in the present drawing, which portrays him as a powerful presence, an unselfconscious man, both humble and enlightened.

68 JACQUES CALLOT
French, circa 1592–1635
An Army Leaving a Castle

Brush and brown wash over black
chalk
10.1 x 21.8 cm (4 x 8⁹⁄₁₆ in.)
Cat. I, no. 63; 85.GG.294

An army, with captives and booty, marches, banners aloft, in procession from the gate
of a burning castle or walled city and regroups in the lower right corner to the fanfares
of trumpets. From the battlements, huge tongues of flame reach up into the darkened
sky (the black chalk underdrawing is clearly visible). The captives are guarded in forlorn
groups by soldiers mounted on camels.

Callot's technique of drawing and printmaking in miniature has long been held in
great esteem, the richness of his tiny compositions bearing witness to his exceptional
dexterity and powers of imagination. The action of the figures and their setting are best
appreciated with a magnifying glass.

The purpose of the study is not known, but it seems likely that it and a pendant
drawing, also in the Getty Museum's collection, were made for engraving, though
no such prints are known. Nor are the outlines of the two drawings gone over with
the stylus for transfer, a further indication that no copperplate was prepared for
either composition. In style, subject, and horizontal format, this drawing resembles
compositions from Callot's etchings, the *Grandes Misères de la guerre* (1633), which
were done immediately after Cardinal Richelieu's devastating invasion of Lorraine,
though the dimensions are slightly smaller than those of the prints.

Callot was one of the most accomplished of all etchers and one of the first great
artists to work exclusively as a printmaker. At his death, he left a prodigious number
of plates—over fourteen hundred!

69 NICOLAS POUSSIN
French, 1594–1665

Apollo and the Muses on Mount Parnassus

Pen and brown ink and brown wash
17.6 x 24.5 cm (6¹⁵/₁₆ x 9¹¹/₁₆ in.)
Cat. I, no. 82; 83.GG.345

Mount Parnassus, a few miles north of Delphi, is celebrated as one of the chief seats of the sun god Apollo and the nine Muses and as an inspiring source of poetry and song. Apollo, seated to the left of center, plays a viol, while outside the circle of Muses surrounding him are figures of poets. The brook in the center foreground is the Castalian Spring, likewise a source of poetical and musical inspiration.

This is a preparatory study for Poussin's picture of the subject in the Museo Nacional del Prado, Madrid, now generally dated about 1630–32. The painting closely follows the overall design of the drawing but differs considerably in the poses of the figures, except for that of the poet at the extreme left striding into the composition, who is much the same in both works. Raphael's well-known fresco of this theme in the Stanza della Segnatura in the Vatican, painted in 1511, and more particularly an engraving after an early version of Raphael's design, by Marcantonio Raimondi, so strongly governed Poussin's idea that the Prado picture must be seen as his act of paying homage to this great master of the Italian High Renaissance. The drawing is remarkable for its economy of line and abstract simplification of form: the foliage of the trees is rendered by a few shorthand notations, while the geometrical forms of the figures have a starkness entirely in keeping with the severity of Poussin's mind.

70 CLAUDE LORRAIN
(Claude Gellée)
French, 1600–1682
*Coast Scene with a Fight
on a Boat*

Pen and brown ink and reddish-brown
wash, heightened with white
bodycolor, on light-blue paper
23.7 x 33.9 cm (9⅜ x 13⁵⁄₁₆ in.)
Cat. I, no. 77; 82.GA.80

Claude was one of the greatest of all landscape painters. Like his near-contemporary Nicolas Poussin, Claude spent most of his career in Rome, and his work was strongly inspired by the Roman Campagna—the nearby countryside of plains, mountains, and sea so evocative of the pastoral serenity of a Golden Age. The basic themes of nature, the ideal, space, light, harmony, repose, biblical story, and classical myth interlock in Claude's pictures to engender an extraordinarily poetic feeling. Perhaps more than anything else, Claude showed his great mastery over light: his compositions portray limpid skies and misty atmosphere that seem to sparkle from the trees, lakes, and buildings.

The drawing is a study, with differences, for the picture commissioned by François-Annibal d'Estrées, Marquis de Coeuvres, the French ambassador in Rome from 1638 to 1641, now in a private collection, though it has also been suggested that it may be a *ricordo* (see no. 28) after the picture. The significance of the men on the boat fighting two on the shore is unclear; in the painting, as well as in a drawing in the British Museum, the skirmish takes place on a bridge and with more participants.

71 HYACINTHE RIGAUD
French, 1659–1743
Portrait of a Man

Brush drawing in gray wash over
black chalk, heightened with white
bodycolor, on light-blue paper
35.4 x 28 cm (14 x 11 in.)
Cat. II, no. 74; 86.GB.612

The identity of the sitter remains unknown. He was at one time believed to be
François-Michel Le Tellier, Marquis de Louvois (1641–1691), Secretary of War to
Louis XIV, a man notorious for his persecution of Protestants as well as for the despotic
power he wielded over the army and the king. In the disagreeable demeanor; the
penetrating look to the eye; the long, rather broad nose; even the set to the chin, there is
some resemblance to Louvois. The principal difference is that Louvois, from his early
twenties onward, wore a distinctive pencil mustache, clearly absent from the lip of the
present sitter, and was generally plumper in the face. Moreover, the drawing seems to be
later, about 1710. Whoever he is, the opulent surroundings—a classical column draped
with damask, a velvet-covered chair on the back of which he rests his left hand, and the
cloak about his waist—serve to emphasize his power and wealth. The artist has lavished
particular care on the description of the texture of the clothes: the silk jacket and linen
shirt with lace-trimmed sleeves and collar are beautifully rendered with white highlights.

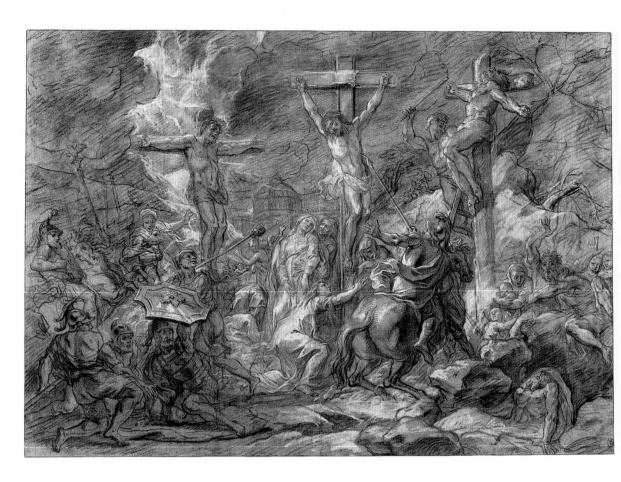

72 ANTOINE COYPEL
French, 1661–1722
The Crucifixion

Red and black chalk, heightened with
white bodycolor
40.5 x 58.1 cm (15¹⁵⁄₁₆ x 22⅞ in.)
Cat. II, no. 54; 88.GB.41

Coypel was one of a family of French painters. Early in his career he studied at the
French Academy in Rome, where he was influenced by the then-prevailing style of
French Classicism. Following his return to Paris in 1675/76, he led a successful career
as a painter of official commissions, which included his most famous work, the ceiling
decoration of the chapel of the palace of Louis XIV at Versailles, painted in 1708, a
Baroque decoration closely based on Italian models. In the theoretical discussions that
took place in Paris at the end of the seventeenth century between the *Rubénistes* (those
artists who favored the exuberant and colorful style of the Flemish painter Rubens)
and the *Poussinistes* (proponents of Poussin's classicism and of the importance of lucid
composition), Coypel was a spokesman for the *Rubéniste* faction.

The drawing is a preparatory study for a painting commissioned in 1692 by the
duc de Richelieu and first exhibited in 1699 at the French Salon, the official annual art
exhibition of the Royal Academy of Painting and Sculpture (called the "Salon" from the
Salon d'Apollon in the Louvre, where the exhibitions were held). The painted work
(Toronto, private collection) includes fewer figures, many of which are posed differently
from their counterparts in the drawing. Perhaps ironically, the composition is closely
dependent on Poussin's great picture of 1644 of the same subject, now in the
Wadsworth Atheneum, Hartford, Connecticut.

73 ANTOINE WATTEAU
French, 1684–1721
*Two Studies of a Flutist and
One of the Head of a Boy*

Red, black, and white chalk
on buff-colored paper
21.4 x 33.6 cm (8⁷/₁₆ x 13³/₁₆ in.)
Cat. II, no. 79; 88.GB.3

Watteau's sureness of touch and crispness of accent make him one of the great
draftsmen of the Western European tradition. His friend the picture dealer
Edme-François Gersaint recognized this great facility and maintained that the artist's
drawings were to be prized above his paintings. Watteau was especially sensitive to the
play of light on drapery and possessed a genius for distilling the essence of a given pose.
Most of his drawings are of the human figure, usually two or more studies to the sheet
as in this example, but with the compositional relationship between the studies often
left unclear. He was a master of the technique known in French as *trois crayons,* a
combination of red, black, and white chalks, usually on tinted paper.

In this sheet the artist has well observed the particular exertion of the fluteplayer—
the unflattering, pent-up expression the musician must make as he directs his breath
through pursed lips is set against the graceful movement of his fingers on the keys as he
holds the instrument elegantly to one side. Although, characteristically, the connection
of the three studies—one of the head of a boy onlooker and the other two of the
flutist in different positions—is undefined, they seem to combine in the spectator's
imagination to form a single scene.

Watteau was greatly influenced by Rubens, in whose work lay the origin of
Watteau's well-known pictorial type, the *fête galante*—compositions showing a world
of enchantment in which elegant young men and women dally in an open landscape
to the sound of music, captivated by feelings of love.

74 FRANÇOIS BOUCHER
French, 1703–1770
Reclining Guitar Player

Black, red, and white chalk on
light-blue paper
27.9 x 44.1 cm (11 x 17 ⅜ in.)
Cat. I, no. 60; 83.GB.359

The figure appears in reverse, with a large musical score propped up in his lap, in the right foreground of the tapestry *The Charlatan and the Peep Show*, where he is one of a trio of figures, the two others being a young couple who study another musical score from which they are about to sing. Boucher has drawn the youth with the reversal in mind, since he has shown him with the stem of the guitar in his right hand instead of his left so that the instrument would be held correctly when the figure was transposed in the finished tapestry (for an explanation of the reversal of tapestry designs as part of the process of transfer, see no. 11). The *trois crayons* technique (see no. 73) is attractively handled on a light-blue paper background.

The Charlatan and the Peep Show is the first in a series of fourteen tapestries known as *Les Fêtes italiennes* or *Les Fêtes de village à l'italienne*, which the artist designed between 1734 and 1746. The composition shows a charlatan or saltimbank on a stage among ruins selling potions, aided by a woman accomplice with a monkey. To the right of the stage is a peep show, while in the foreground are desultory groups of figures, including children and the group of singers already mentioned.

Boucher was one of the great decorative painters of the French Rococo. In 1723 he went to Rome to study at the French Academy. On his return to France in 1731 he quickly gained the favor of the French court, including the powerful Mme de Pompadour, Louis XV's mistress.

75 LOUIS CARMONTELLE
(Carrogis)
French, 1717–1806

*The Duchess of Chaulnes
as a Gardener in an Allée*

Watercolor and bodycolor
over red and black chalk
31.7 x 19 cm (12½ x 7½ in.)
Cat. III, no. 93; 94.GC.41

In 1758, Marie d'Albert de Luynes, the fourteen-year-old daughter of the duc de Chevreuse and granddaughter of the duc de Luynes, married her cousin, Marie Joseph Louis d'Albert d'Ailly, the vidame d'Amiens, who later became duc de Picquigny and, in 1769, duc de Chaulnes. Her husband left for Egypt the day after their wedding and stayed there for several years. On his return he refused to see her and to consummate the marriage. Condemned to lifelong virginity, she dressed in white, as seen in this rendering.

The vogue for gardening among women of noble rank gained in popularity with the ardent support of Queen Marie Antoinette, who followed the pastime at the Royal Palace of Versailles, most notably at the famous Hameau, her mock-Norman farm built in the palace garden.

This is one of a series of some 750 portraits that Carmontelle drew of members of the court of the duc d'Orléans. At its numerous social events held at the Palais-Royal in Paris, Carmontelle entertained the guests by making portrait drawings on the spot in the technique of *trois crayons* (see no. 73), to which he subsequently added watercolor and bodycolor. The artist later bound them together into eleven albums, and the whole group forms an exhaustive record of court personages and court life before the French Revolution, with Mozart, Voltaire, and Franklin among the sitters.

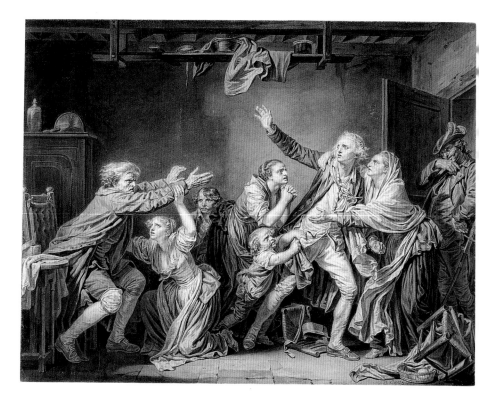

76 JEAN-BAPTISTE GREUZE
French, 1725–1805
The Father's Curse:
The Ungrateful Son

Brush and gray wash,
squared in pencil
50.2 x 63.9 cm (19¾ x 25³⁄₁₆ in.)
Cat. I, no. 74; 83.GG.231

In this scene of paternal malediction, the father extends his hands in anger toward his son who has just enlisted in the army. A young girl kneeling in front of the father is trying to pacify him, while the mother embraces her son; on the threshold of the door the recruiting sergeant contemplates the spectacle with indifference. The drawing corresponds closely with Greuze's famous picture of the same title in the Musée du Louvre, Paris, painted in 1777–78. The pendant picture, *The Father's Curse: The Son Punished,* also in the Louvre, shows the same family at the old man's deathbed giving vent to its grief, as the son, who has now returned to the paternal roof, repents too late of his misconduct.

Late twentieth-century taste is not attuned to Greuze's moralistic storytelling, but his attraction to the protectors of religion and morality of his own day ensured his contemporary success. The vogue for sentimental, moral subjects to which his work appealed arose in mid-eighteenth-century French painting partly as the result of the influence of English novels and the moralistic writings of such famous contemporary authors as Jean-Jacques Rousseau, whose speculations on moral, social, and political topics caught the popular mood.

The overserious content of many of Greuze's pictures is often the target for mockery, as in this passage from the nineteenth-century French critics the Goncourt brothers:

> Examine his work: You will observe how, having sought to embellish beauty, he proceeds to adorn poverty and destitution. Look at his children, his little tatterdemalions with their torn trousers; are they not, in fact, Boucher's cupids who have dressed themselves up as chimney sweeps and broken into the house by coming down the chimney? It is as if the hand of a theatrical producer had had a finger in all his compositions: The figures act, group themselves in a *tableau vivant,* their occupations are artificially regulated, their work is a mere semblance.

**77 JEAN-HONORÉ
FRAGONARD**

French, 1732–1806

*"Oh! If Only He Were
as Faithful to Me!"*

Brush and brown wash over black
chalk

24.8 x 38.3 cm (9¾ x 15⅛ in.)

Cat. I, no. 69; 82.GB.165

The abandoned young woman, dressed only in a neglige, kneels on her unmade bed
with her hands clasped in despair and fixes a yearning gaze on her little dog. The
faithfulness of the pet, which stares back at her devotedly, is a foil for the waywardness
of her absent lover. He is reproached in her sigh, *"S'il m'était aussi fidèle!"*—the
sorrowful quote that forms the title of an engraved version of the composition by
Abbé de Saint-Non, published in 1776. If the mood seems exaggeratedly dire, there
is a compensating touch of humor. The wronged young woman depends in pose on
representations of the penitent Saint Mary Magdalene, the reformed courtesan of the
New Testament who anointed Christ's feet and whose hair is similarly untied, long and
flowing.

Fragonard's drawings in brush and wash are among the most accomplished of the
whole eighteenth century. His facility in the medium is astonishing. Especially well
judged are his light, fluent washes that here convey the sense of abandonment of the
very bedclothes; such passages contrast with the arrestingly exact precision of the small
marks with the point of the brush that make up the eye, nostril, and mouth of the girl's
attractive profile and are the essence of her expression of sexual regret that so permeates
the work. The drawing is one of a number devoted to erotic themes carried out by the
artist in the later 1760s.

Fragonard's freely painted and colorful pictures of landscape and history subjects
are among the most complete embodiments of the French Rococo style.

78 JEAN-MICHEL MOREAU THE YOUNGER
French, 1741–1814
"Have No Fear, My Good Friend!"

Pen and gray ink and brown wash
26.7 x 21.6 cm (10½ x 8½ in.)
Cat. I, no. 81; 85.GG.416

The drawing was engraved in the *Monument du costume* (1776), a series of prints that illustrate the life of a woman of society and intended to represent fashionable life of the time. The heroine, Céphise, reclines on a settee, apprehensive about her impending first confinement. The following snippet of conversation between her and the marquise (the earnest-looking woman seated in front of her) and the abbé (the man standing to the left with a somewhat haughty expression), taken from the text accompanying the prints, sets the scene: "The moment it [the birth] is over, you won't give it a thought… I have had four children and am none the worse for it."

The title of the composition is their exhortation to Céphise; the title of the next composition in the series, "It's a boy, sir" (the announcement of the happy news to the husband), settles their point.

The artist has signed and dated the work in the lower left corner: *JM moreau le jeune. 1775.*

79 JACQUES-LOUIS DAVID
French, 1748–1825
*The Lictors Returning to Brutus
the Bodies of His Sons*

Pen and black ink and gray wash
32.7 x 42.1 cm (12⅞ x 16⁹/₁₆ in.)
Cat. I, no. 68; 84.GA.8

The drawing, which is signed and dated on the base of Brutus's chair *L. David faciebat 1787,* is a study for the well-known painting of the subject in the Musée du Louvre, Paris, commissioned by Louis XVI and completed in 1789, the very year of the French Revolution.

The subject, which is full of republican overtones, is taken from ancient Roman history. Junius Brutus, in 509 B.C. one of the first two Roman consuls instituted after the fall of the Tarquins, the family of tyrannical kings of Rome, is here shown soon after the execution of his two "royalist" sons, who had betrayed him by attempting to restore the Tarquins. Brutus is seated at the foot of the statue of the goddess Roma; in the painting, he holds in his hand the letter written by his sons to Tarquin. On the right, his wife and daughters succumb to their grief at the sight of the lictors bringing back the bodies. "Thus patriotic duty overcomes the mere responsibility of the father, and family happiness is subverted by political loyalty."

David was one of the great Neoclassical painters of his age. He was in active sympathy with the French Revolution, giving expression in his paintings to the new sense of civic virtue that it heralded. He was later official painter to Napoleon Bonaparte.

80 JACQUES-LOUIS DAVID
French, 1748–1825

Portrait of André-Antoine Bernard, Called Bernard des Saintes

Pen and india ink and gray wash, heightened with white bodycolor, over graphite
Diam. 18.2 cm (7⅛ in.)
95.GB.37

During the French Revolution, between Thermidor 10 and 12, year II (July 28–30, 1794), Robespierre and about a hundred of his followers were guillotined, thus ending the Reign of Terror. Soon thereafter charges were brought against David, for his support of Robespierre and his signing of a number of arrest warrants while serving as a member of the Committee on Public Safety. David was arraigned on August 3 and imprisoned, first in the Hôtel des Fermes and later in the Palais du Luxembourg until his release on December 28. On May 28, 1795, he was rearrested and incarcerated in the Collège des Quatre-Nations, from which he was freed on August 4.

While in the Quatre-Nations, he made a number of portrait drawings of fellow prisoners that comprise a vivid pictorial record of personalities from the French Revolution. Among the most striking of the group is this example of the lawyer André-Antoine Bernard. A participant in the *Assemblée législative* in 1791 and a deputy at the *Convention nationale* in 1792, Bernard was imprisoned in the Quatre-Nations with David, who made the portrait on July 24, 1795, according to an old inscription on the drawing's backing. Released in October of that year, Bernard was exiled in 1816 for having voted to execute Louis XVI; he went to Brussels and then emigrated to America, where he died.

David's intense portrayal of Bernard des Saintes seems to extend beyond its function as an individual likeness to evoke the drama of the revolution in which both artist and sitter had played a part.

**81 ANNE-LOUIS GIRODET
DE ROUCY TRIOSON**
French, 1767–1824

*Phaedra Rejecting the Embraces
of Theseus*

Pen and brown and gray ink,
heightened with white bodycolor,
over graphite
33.5 x 22.6 cm (13¼ x 8⅞ in.)
Cat. I, no. 71; 85.GG.209

This is a highly finished preparatory study for
one of the illustrations to a deluxe edition of
the work of the great seventeenth-century
French tragedian Jean Racine, published by
Didot between 1801 and 1805. Girodet was
one of seven artists from the circle of Jacques-
Louis David who collaborated on the project,
being responsible for five illustrations each for
Andromaque and *Phèdre*. This drawing shows
the moment when Theseus returns and is
shocked by the cold reception he receives
from his wife and from his son Hippolytus.

The controlled compositional balance and clarity of both meaning and form are
exemplary of the entire series of illustrations. One critic regretted these qualities,
observing that the engravings "resemble copies after bas-reliefs; they show the
personages as imposing, immobile, and as cold as marble, the figures geometrical and in
rectilinear attitudes," commenting further that the illustrators would have better "taken
as their starting-point the work of Racine himself." Be that as it may, the compositions
are undoubtedly a reflection of the profound impact of David's austere Neoclassical
style on French taste at the beginning of the Napoleonic era.

**82 JEAN-AUGUSTE-
DOMINIQUE INGRES**
French, 1780–1867

*The Duke of Alba Receiving the
Pope's Blessing in the Cathedral
of Sainte-Gudule, Brussels*

Pen and brown ink, and brown wash,
heightened with white, over black and
red chalk and graphite
43 x 52.9 cm (16¹⁵⁄₁₆ x 20¹³⁄₁₆ in.)
95.GA.12

The drawing shows Fernando Álvarez de Toledo, Duke of Alba, receiving from the
archbishop of Mechelen a hat and sword blessed by Pope Pius V. The scene is the
Cathedral of Sainte-Gudule in Brussels, where Alba is being honored for suppressing
Protestant heresy. In 1566, Philip II of Spain sent the duke to reestablish the king's
authority in the Netherlands and to root out Protestantism. As the tyrannical governor
general from 1567 to 1573, Alba formed the so-called Council of Blood, which set
aside local laws and condemned some eighteen thousand Protestants to death.

This is an elaborate, fully worked-out study, with considerable differences, for the
unfinished painting commissioned by the fourteenth duke of Alba, which Ingres
worked on between 1815 and 1819. Disturbed at having to celebrate a man for his
cruelty and religious intolerance, Ingres, who was born in Montauban, a traditional
stronghold of French Protestantism, did not complete it. Although the drawing gives
the appearance of a successfully resolved composition, the painting is changed to an
upright format and the duke is no longer the principal protagonist. The artist has
removed him from the foreground, placing him instead, a diminutive figure, on a
throne at the top of a high dais, carpeted in the brightest red, which gives the whole
scene the sense of being bathed in blood. (It is one of the ironies of history that the
picture was looted by the Nazis and ended up in the possession of Marshal Göring;
after its recovery at the end of World War II, it was allocated to the Musée Ingres.)

Ingres Del. Rome.
1816

**83 JEAN-AUGUSTE-
DOMINIQUE INGRES**
French, 1780–1867
Portrait of Lord Grantham

Graphite
40.5 x 28.2 cm (15¹⁵⁄₁₆ x 11⅛ in.)
Cat. I, no. 76; 82.GD.106

As an impoverished young artist living in Rome, Ingres earned his living almost entirely
from drawing portraits of wealthy visitors to the city, though he despised the activity,
regarding history painting as his true vocation. "Damned portraits…they prevent me
from getting on to great things," he once complained. But none of his reluctance
emerges in this vivid likeness, whose abstract purity of line is so typical of the artist's
best portraiture—a sense of refinement that made his wealthy, noble patrons return to
him for more portraits.

This drawing is signed and dated: *Ingres Del. Rome./1816*. The sitter, the English
peer Thomas Robinson, third Baron Grantham and later Earl de Grey, was thirty-five
when he submitted himself to Ingres for his portrait. It must have been at the artist's
request that Grantham removed his right glove, tucked his right hand behind the
buttoned-down front of his tailed jacket, and crooked his arm to establish a dynamic
counterpoint to the relaxed appearance of the rest of his body—the left arm hanging
down limply, with the gloved hand holding his top hat and right glove, and the half
"at ease" position of the legs. For all this, the handsome young nobleman looks back
at the spectator a little shyly. The drawing shows the Basilica of Saint Peter in the
background, viewed from the Arco Oscuro, a vantage point that Ingres chose also
for other portraits.

84 THÉODORE GÉRICAULT

French, 1791–1824

The Giaour

Watercolor and bodycolor
over graphite
21.1 x 23.8 cm (8⁵⁄₁₆ x 9³⁄₈ in.)
Cat. II, no. 60; 86.GC.678

Subjects taken from the works of the great English Romantic poet Lord Byron were popular on the Continent from the time of their first appearance. *The Giaour: A Turkish Tale*, 1813, is a story about a Christian outlaw of the time of the Crusades. This drawing illustrates the passage in which the giaour, defying the hostile elements and overcoming his horse's fear, surveys with rage a distant Turkish town in the dead of night:

> He spurs his steed; he nears the steep,
> That, jutting, shadows o'er the deep;
> …
> His brow was bent, his eye was glazed;
> He raised his arm, and fiercely raised,
> And sternly shook his hand on high.

Géricault well captures the hero's sense of resolve in this watercolor of around 1820, done for a lithograph (what was then a new process of printing from a stone block) published in 1823, in which the Turkish town appears in the lower left. The moonlit scene, with dark, threatening sky, wind-blown rock, and distant sea, shows Géricault responding positively to the popular literary Romanticism of the time. He also pays lip service to the contemporary fashion for things Islamic, a vogue that stemmed in part from Napoleon's campaigns in Egypt and Syria at the turn of the century.

Géricault was one of the originators of the Romantic movement in French painting. His art was greatly affected by his passion for horses, which he represented with remarkable understanding, as in this example.

85 EUGÈNE DELACROIX
French, 1798–1863
The Death of Lara

Watercolor with some bodycolor
over underdrawing in graphite
17.9 x 25.7 cm (7¹⁄₁₆ x 10⅛ in.)
94.GC.51

The subject is taken from *Lara,* a poem by Lord Byron published in 1814. Lara, a Spanish overlord, returns from exile accompanied by Kaled, a page "of foreign aspect, and of tender age," only to encounter the wrath of a neighboring baron, Otho. Lara becomes the leader of a peasant revolt, which is eventually suppressed by Otho. In a final battle against overwhelming odds, the hero is mortally wounded by an arrow. He dies in the care of his faithful Kaled, who in the end is revealed to be a maiden in disguise who is in love with him.

In this watercolor Kaled is patently a young woman, her distant origin symbolized by her cap and her plaid or tartan cloak. In the mid-to-late 1820s, the probable date of the watercolor, Delacroix made a special study of armor and of tartans. More importantly, his knowledge is here revealed of the brightly colored watercolors of history subjects by the early nineteenth-century English painter Richard Parkes Bonington, who was active mainly in France.

Delacroix was the greatest painter of the French Romantic movement. As the freedom of touch and brightness of color of his paintings grew, he came more and more into conflict with the exponents of the great French classical tradition of painting, notably Ingres.

86 HONORÉ DAUMIER
French, 1808–1879
A Criminal Case

Watercolor and bodycolor, with pen
and brown ink and black chalk
38.5 x 32.8 cm (15⅛ x 12¹³⁄₁₆ in.)
Cat. II, no. 55; 89.GA.33

Daumier's first job as a youth was as an errand boy to an usher at the Palais de Justice
in Paris. From an early age he was thus able to watch the comings and goings of
lawyers in their dark flowing robes, accompanied by their bedraggled, despondent,
even bestial-looking clients from the criminal classes. With remarkable candor,
Daumier studied the interaction between these two groups, the lofty and impatient
gestures of the advocates contrasting with the helpless expressions of their ignorant
victims, tangled within the complex mesh of the judicial system. In this drawing the
murderer leans over the dock to "consult" with his lawyer, who is clearly in control of
the exchange, governing it by his raised right hand and pointing index figure and by his
seizure of a sheaf of papers for reference. The guard stands behind, impassive as a dolt,
oblivious to the meaning or purpose of the conversation. The drawing may have been
done as an end in itself, though it depends to some extent on a lithograph (see no. 84)
of 1846, one of his series *Les Gens de Justice,* 1845–48.

Principally a caricaturist but also a painter and sculptor, Daumier is best known
for the political cartoons he regularly contributed to the antigovernment weeklies *La
Caricature* and *Le Charivari*. On average he designed two such cartoons a week and is
said to have made over four thousand lithographs by the time of his death.

87 HENRI LEHMANN
(Karl Ernest Rodolphe
Heinrich Salem Lehmann)
French, 1814–1882
*Lamentation at the Foot
of the Cross*

Gray wash, heightened with white
chalk, over black chalk and graphite,
on brown paper
42.8 x 29.2 cm (16⅞ x 11½ in.)
Cat. II, no. 63; 86.GB.474

This is a finished preparatory study for Lehmann's picture of the subject in the Chapelle
de la Compassion, Church of Saint-Louis-en-l'Île, Paris, painted in 1847. Lehmann
was inspired by *The Descent from the Cross,* painted in 1789 by Jean-Baptiste Regnault
for the chapel of the Château de Fontainebleau (Paris, Musée du Louvre).

The drawing exemplifies the fashionable academic style that so dominated the
art of the French Salons (see no. 72) from the middle of the nineteenth century to
the beginning of the twentieth. The long-standing twentieth-century vogue for
Impressionism and Post-Impressionism has tended to hinder our appreciation of the
many excellent qualities of this official style of painting, which favored history subjects
above all other genres and admired a neo-Greek model that also allowed for multiple
references to the great painting of the past. It is only recently that the work of these
"official" painters, such as Lehmann, has come to be appreciated on its own terms for
its gracefulness, remarkable proficiency of execution, and independent poetic power.

Lehmann's speciality was history painting, often of scriptural subjects, such as the
present example. He was employed in mural decorations, among them the galleries of
the Hôtel de Ville, Paris. In 1861 he was made head of the Académie des Beaux-Arts,
and in 1875 professor at the École des Beaux-Arts.

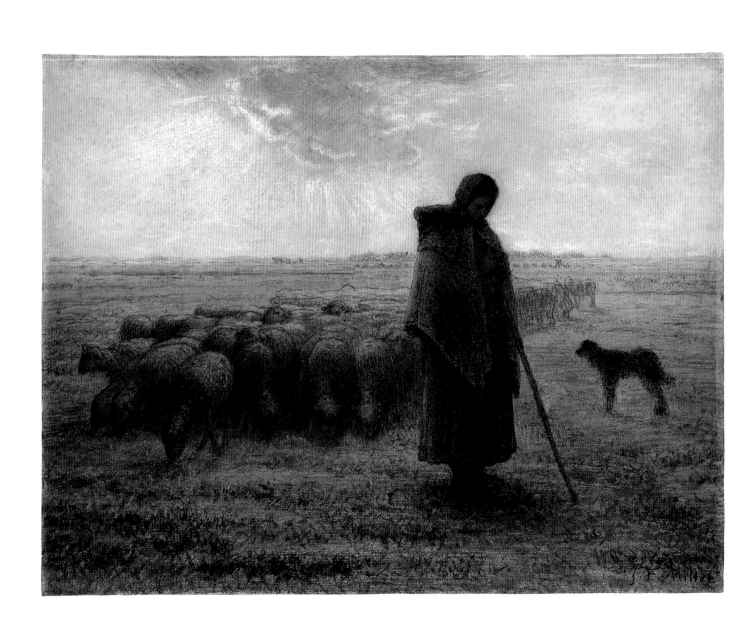

88 JEAN-FRANÇOIS MILLET
French, 1814–1875
A Shepherdess and Her Flock

Pastel
36.4 x 47.4 cm (14 ⅜ x 18¹¹⁄₁₆ in.)
Cat. I, no. 80; 83.GF.220

A cloud has passed over the sun, casting the scene into gloom. The shepherdess, her flock of sheep, and the sheepdog stand half-silhouetted against the pale sky and the weakly lit surface of the field. Waiting patiently and with dignity was part of the endless routine of the peasant, whose simple life Millet sought to ennoble in his work, which brought him accusations by contemporary critics of Socialist leanings.

In the Salon of 1864 Millet exhibited his painting *A Shepherdess and Her Flock* (Paris, Musée du Louvre), which received great acclaim as one of his classic depictions of peasant life. This is one of several pastels connected in composition to that work—two are in the Museum of Fine Arts, Boston; one in the Walters Art Gallery, Baltimore; and one was formerly on the art market, New York.

The son of a peasant farmer from Normandy, Millet was inspired by his rural background to make peasant life the subject of his painting. From 1849, he joined a group of painters working at Barbizon, a small village at the edge of the Forest of Fontainebleau, whose mission was to paint from nature directly as they saw it, and whose work together constitutes the Barbizon school, an important forerunner of the Impressionist movement.

89 ÉDOUARD MANET
French, 1832–1883
Bullfight

Watercolor and bodycolor
over graphite
19.3 x 21.4 cm (7⁹⁄₁₆ x 8⁷⁄₁₆ in.)
94.GC.100

The composition is reminiscent of the painting *Episode in a Bullfight,* which Manet exhibited at the Salon of 1864 and then cut up following adverse criticism; the lower section, *The Dead Toreador,* is in the National Gallery of Art, Washington, D.C.; the upper, *Toreadors in Action,* which strongly recalls the upper part of this drawing, is in the Frick Collection, New York.

In August 1865 Manet travelled to Spain, a visit that was profoundly to influence the rest of his career. In a letter that September to a friend he mentioned a "superb" bullfight he had witnessed: "You can count on it that upon my return to Paris I shall put the fleeting aspect of such a gathering of people onto canvas." He also wrote of the "dramatic part, with picador and horse upended and gored by the bull's horns and a horde of ruffians trying to control the furious beast." Manet's picture of the subject (Paris, Musée d'Orsay) was painted in the same year, though it differs considerably from the drawing in its wider angle of vision, which allows more space for the artist's interest in the crowd but diminishes the dramatic focus on the bull savaging the picador's horse.

Manet was one of the most prodigiously gifted painters of all time, his brushwork remarkable for its naturalness and fluency. His liking for popular subject matter (at the time construed as offensive) established him in the forefront of avant-garde painting of the day. Beginning with *The Absinthe Drinker* (Copenhagen, Ny Carlsberg Glyptotek), rejected by the Salon jury in 1859, and culminating in the *Déjeuner sur l'herbe* and *Olympia* of 1863 (both Paris, Musée d'Orsay), his work was widely acclaimed as the "painting of modern life," for which the eminent nineteenth-century critic Charles Baudelaire had so long appealed. Although he refused to take part in the Impressionist exhibitions of the 1870s, Manet nevertheless influenced most of the members of the group.

90 EDGAR DEGAS
French, 1834–1917
Self-portrait

Oil on paper, laid down on canvas
20.6 x 15.9 cm (8⅛ x 6¼ in.)
95.GG.43

Drawing, which underlies every form of pictorial or plastic expression, often overlaps with other media. Although drawings are invariably made on paper, not all works on paper necessarily spring to mind as drawings. Sketches like this *Self-portrait* by Degas or *The Entombment* by Barocci (no. 22), both in oil on paper, straddle the divide between drawing and painting. Seen by some as a painting because of the medium employed, Degas's *Self-portrait* is a work on paper and has the directness of touch and intimacy associable with a drawing.

Degas made this *Self-portrait* around 1857–58, during his youthful sojourn in Italy. The period was one of self-education, and he painted and drew prolifically. Following the advice given him by Ingres, he devoted much of his time to making copies after Renaissance masters. Like many young artists, Degas found that he himself was his most amenable sitter: while in Italy, he made fifteen or more self-portraits in various media, most of which show him three-quarter face with his eyes turned to the side to look piercingly at himself, and hence at us.

Degas's grounding in the Old Master tradition gave his work a strength of form that sets it apart from the Impressionist and Post-Impressionist painters with whom he is usually grouped. His introduction to this circle occurred in 1862 after his meeting with Manet, an association that resulted in his turning from history painting to subjects from contemporary Parisian life—scenes of racecourses, cafés, ballet, theater, washerwomen, and brothels (see nos. 91–92).

91 EDGAR DEGAS
French, 1834–1917
Procession at Saint-Germain

Graphite
24.8 x 33 cm (9¾ x 13 in.)
95.GD.35

This is a sketch from an album of pencil sketches drawn by Degas around 1877 (see no. 92). The inscription, in the hand of Ludovic Halévy, identifies the studies as being from a procession at the Church of Saint-Germain in Paris, in June 1877. It is easy to see why the different subjects caught the artist's eye: the little girl with a pretty hairstyle holding a candle, bottom left; the haughty man with a flower in his buttonhole, immediately behind her; the eccentric-looking priests, including the balding one in profile, with a coif at the front of his head and the remnant of hair at the back brushed forward; and the array of not-so-good-looking middle-aged women on the right. Drawn with great rapidity, the line is muscular, economical, and sure. Each head is a recognizable, particularly observed individual, and there is no trace of repetition or relapse into formula, so often a weakness of caricature.

The row of three female heads in profile, or near profile, top right, should be compared with the caricature "cameo" of three bearded men in profile, top right of the Agostino Carracci drawing (see no. 25). Both the Carracci and the Degas are within the tradition of grotesque or caricature drawing that goes back to Leonardo da Vinci.

92 EDGAR DEGAS
French, 1834–1917
Reyer with Washerwomen

Graphite
24.8 x 33 cm (9¾ x 13 in.) (each folio)
95.GD.35

Like no. 91, this drawing is from an album of pencil sketches made by Degas around 1877, during weekly soirées at the household of his friend Ludovic Halévy, a writer of opera librettos (including Bizet's *Carmen*) and popular romances, as well as a keen follower of ballet, like Degas himself. According to Halévy, at these evening gatherings Degas would draw members of the company as well as make studies for his own work. The sketches embrace a variety of themes but are mostly of the café-concert and ballet and reflect Degas's constant processing and reprocessing of material for his paintings and prints. Altogether thirty-eight of the artist's sketchbooks survive, twenty-nine in the Bibliothèque Nationale de France, Paris.

These pages show the composer Ernest Reyer sitting among washerwomen. The inscription at the top of the page states that "for a long time Reyer has been offering a

third-floor [and thus cheap theater] box to a washerwoman." He is shown sheepishly proffering a slip of paper to the woman holding an iron somewhat coquettishly to her cheek in order to judge its heat. Although the precise meaning of Reyer's offer is unclear, there may be a sexual inference, especially given the fact that, in the nineteenth century, washerwomen often turned to prostitution to supplement their low income.

In spite of a long friendship going back to their schooldays, Degas broke abruptly with Halévy in 1898, following the infamous Dreyfus scandal. Although brought up a Catholic, Halévy was Jewish; in the polarization of Parisian society that resulted from the scandal, Degas was determinedly anti-Dreyfus and therefore strongly anti-Semitic. This twist brings poignancy to the book, which long remained in the possession of the Halévy family and is so patently a document of profound artistic friendship.

93 PAUL CÉZANNE
French, 1839–1906
Still Life

Watercolor over graphite
48 x 63.1 cm (18¹⁵⁄₁₆ x 24⅞ in.)
Cat. I, no. 65; 83.GC.221

Datable around 1900, this is perhaps the most finished of a group of large watercolors of still-life subjects made toward the end of Cézanne's career. This example is close in composition to a watercolor in the Ford Collection, Grosse Pointe Shores, Michigan, which seems to precede it in execution. The Getty Museum's watercolor is remarkable not just for its scale, degree of finish, and overall quality but also for its exceptional state of preservation.

Cézanne's monumental conception of form is seen here: the jug, the two pots—one white, one blue—and the apples indeed assume a physical presence greatly beyond our normal perception of their existence. These elements, together with the tablecloth, tapestry cover, and background wainscot and wall, are represented according to the artist's highly personal use of watercolor, in small, superimposed patches of translucent tint that somehow evoke the plasticity of substance with extra resonance, in spite of the apparent frailty of the medium. The contrast between these intense passages of color and the untouched areas of paper merely emphasizes this powerful physical effect.

Cézanne was probably the greatest and most influential of the painters loosely termed Impressionist who were active in France toward the end of the nineteenth century. He brought to the fleeting quality of Impressionism, with its freedom of touch and use of small brushstrokes, a new abstract, intellectual force that gave his pictures a sense of classical, rational, and therefore timeless order.

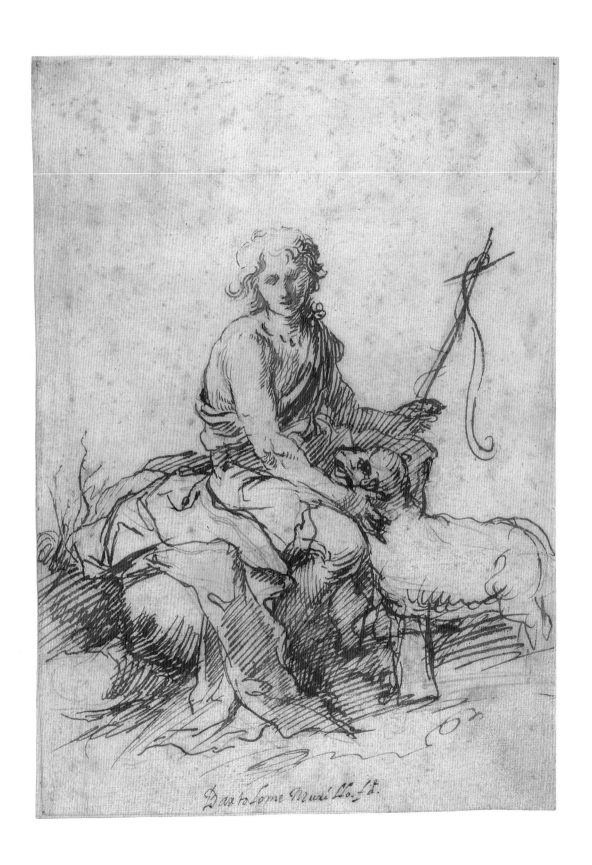

Bartolome Murillo. f.ª

94 BARTOLOMÉ ESTEBAN
MURILLO
Spanish, 1617–1682
*The Youthful Saint John the
Baptist with the Lamb*

Pen and brown ink over black chalk
27.2 x 19.2 cm (10 11/16 x 7 9/16 in.)
Cat. III, no. 114; 94.GA.79

The youthful Saint John the Baptist is seated in the wilderness, holding his reed cross with his left hand and the Paschal Lamb with his right. The Lamb and the accompanying inscription, *Ecce Agnus Dei,* which normally appears on the scroll attached to the cross, derive from the Fourth Gospel (1:36), "And looking upon Jesus as he walked, he [John] saith, Behold the Lamb of God." The drawing may well have been made for a painting, possibly one of a series showing different saints and archangels, since a study identical in style and of about the same size in the British Museum, London, shows the standing figure of the archangel Michael. Like many drawings by Murillo, those in the Getty Museum and in London are identically inscribed, *Bartolome Murillo fat* (short for *faciebat* = "made it," a Latin abbreviation commonly found on prints and drawings): it is not a signature, but a note of authorship, written after the artist's death, possibly by his executor.

Murillo was one of the leading Spanish painters of the seventeenth century. His mature work is naturalistic and strongly tenebrist in style, partly as a result of the influence of his fellow Sevillian, Diego de Velázquez (1599–1660). In later works Murillo softened his earlier stark chiaroscuro into a warmer, more diffuse kind of illumination.

95 FRANCISCO JOSÉ DE
GOYA Y LUCIENTES
Spanish, 1746–1828
Contemptuous of the Insults

Brush and india ink
29.5 x 18.2 cm (11⅝ x 7³⁄₁₆ in.)
Cat. I, no. 142; 82.GG.96

A man with features much resembling those of Goya himself gestures contemptuously (and possibly obscenely) at two disagreeable-looking dwarfs dressed in military regalia who threaten him with daggers; their uniforms have been interpreted by some as those of generals in Napoleon's army. *Despreciar los ynsultos* (Despise the insults) is inscribed below the image, bottom center, a title that seems to signify Goya's defiance toward the French military occupation of Spain. The point is reinforced by the difference in scale between the figures—the tall, urbane Spaniard patronizing his squat and gloomy oppressors.

The drawing is number 16 from the "Dark Border Set" (called Album E), which may originally have contained as many as fifty drawings. The album was made around 1805, some six years after the artist published his famous series of etchings *Los Caprichos* (Caprices), a bitter attack on contemporary customs and manners, and some thirteen years following the mysterious illness that left Goya completely deaf, an event that altered the direction of his work from an extrovert, decorative style to one obsessed with the morbid and bizarre.

Goya was appointed painter to King Charles III of Spain in 1786 and court painter to King Charles IV in 1789. The turmoil that beset Spain during the Napoleonic wars, to which this drawing makes reference, also inspired Goya's *Disasters of War* (1810–23), a series of etchings that show with stark brutality the consequences of such conflict.

Desprecian los ignorantes

**96 THOMAS
GAINSBOROUGH**
British, 1727–1788
*Lady Walking in a Garden
with a Child*

Black chalk with stumping on
light-brown paper, heightened
with white pastel
50.5 x 22.1 cm (19⅞ x 8¹¹⁄₁₆ in.)
96.GB.13

The sitter and her child are unknown, but it is likely that the two figures were intended as portraits of individuals from the English aristocracy. The large picture hat and flamboyant hairstyle were in vogue around 1785–90. According to Gainsborough's friend William Pearce, the artist went on a sketching trip to Saint James's Park in London to draw the "high-dressed and fashionable ladies" in order to prepare his never-executed picture of *The Richmond Water-Walk* (so called from the promenade along the Thames at Richmond, a few miles west of London), which was to show "Richmond Water-Walk, or Windsor—the figures all portraits." This was commissioned around 1785 by King George III as a companion to *The Mall in Saint James's Park* (New York, Frick Collection), a magnificent picture showing elegantly dressed ladies parading along this wooded walk, "all aflutter, like a lady's fan," as one commentator put it.

This drawing, along with two in the British Museum, London, and one in the Pierpont Morgan Library, New York, were probably done from life and are among Gainsborough's greatest figure drawings, with this arguably being the finest of the group. Much the same magical touch as in his best painted work is seen here. The liveliness of the sweeps of charcoal and white highlight is a metaphor for the woman's movement—the turn of her head, the lightness of her step, even the sense of breeze blowing her skirts and gently agitating the surrounding foliage.

Gainsborough's sophisticated and elegant style of portraiture is epitomized by *The Blue Boy* (San Marino, Huntington Library, Art Collections, and Botanical Gardens). His later portraits show a sensitive harmonization of human and natural forms united by brushwork of extraordinary inventiveness and freedom.

97 WILLIAM BLAKE
British, 1757–1827
Satan Exulting over Eve

Watercolor, pen and black ink, and
graphite over color print
42.6 x 53.5 cm (16¾ x 21¹/₁₆ in.)
Cat. I, no. 146; 84.GC.49

Although Blake was one of the greatest British artists of the Romantic period, he is less well known than some of his contemporaries. One reason for this is the poetic and visionary basis of his art, which embodies his own personal philosophy and mythology. His powerful images reflect his visions, which he insisted were not "a cloudy vapour or a nothing; they are organized and minutely articulated beyond all that the mortal and perishing nature can produce." Yet, in spite of this subjective inspiration, the compositional formulae and figure types in his work depend on those of the great Old Master tradition of painting and drawing, works with which he was familiar from engravings.

Just as Degas's *Self-portrait* (see no. 90) belongs to the gray area between painting and drawing, so *Satan Exulting over Eve* straddles drawing and printmaking. It is one of twelve color prints done in 1795 that were made by drawing and brushing a design in broad color areas onto a piece of millboard, printing them on a piece of paper, and working them over considerably in watercolor and pen and ink. Each version of the various designs is therefore unique, and in no case are more than three variants of a design known to survive. Satan flies in malevolent glory over the beautiful nude figure of Eve, who is entwined by his alter ego, the serpent of the Garden of Eden.

Blake was trained as an engraver. Most of his career was spent publishing his own, uniquely illustrated, poetry and prose.

98 SIR DAVID WILKIE
British, 1785–1841
*Sir David Baird Discovering
the Body of Tipu Sahib*

Watercolor, pen and brown ink,
and black chalk
41.6 x 28 cm (16⅜ x 11 in.)
95.GG.13

This is an elaborate compositional study for Wilkie's painting in the National Gallery
of Scotland, Edinburgh, commissioned in 1834 and completed by 1838. The drawing
shows Sir David Baird regarding the body of Tipu Sahib, the last independent sultan
of Mysore, whose capitulation and death marked the final consolidation of British rule
in India. Sir David Baird was defeated in the First Mysore War and was imprisoned
from 1780 to 1784 in Seringapatam, capital of Mysore. He returned to India to lead
the successful storming of the city on May 4, 1799, in which Tipu was killed.

The artist based his composition on a contemporary description of the finding of
the dead sultan: "About dusk, General Baird…came with lights to the gate…to search
for the body of the sultan; and after much labour it was found, and brought from
under a heap of slain to the inside of the gate." In the drawing, Baird stands at the
gateway under which Tipu received his death wound. At Baird's feet is a grating, a
reference to the dungeon in which he himself had been incarcerated.

Wilkie was among the most popular and innovative of the history painters in England
in the first half of the nineteenth century. He was also one of the finest draftsmen of his
period. During the early part of his career, he achieved wide popularity with his peasant
genre scenes, but later he pursued history painting, and his style changed accordingly.
Combining the influence of the great masters of the past with the Romanticism of
contemporary painters, he evolved a new, popular style of history painting.

99 JOSEPH MALLORD
WILLIAM TURNER
British, 1775–1851
Conway Castle, North Wales

Watercolor and gum arabic
with graphite underdrawing
53.6 x 76.7 cm (21⅛ x 30⅛ in.)
95.GC.10

This is the largest and most elaborate of Turner's four surviving watercolors of Conway Castle, a late medieval castle on the northern coast of Wales. The Welsh landscape exerted a strong influence on the young Turner, and he made several sketching trips there in the 1790s; this example was probably made following his tour of 1798. The castle towers over a windy bay as fishermen struggle to pull their boats ashore. Turner's special gift in representing dramatic effects of natural light is seen here as a break in the clouds allows the sunshine to illuminate the building and the coast beyond. The tiny figures of the fishermen caught in this vast expanse prompt thoughts on man's place in the natural world, which is so governed by physical and temporal forces beyond his control.

Turner was the foremost British painter of the first half of the nineteenth century, and one of the great figures in the history of landscape painting. His landscape imagery was transformed into a vehicle whose dramatic power and universality rivaled that of contemporary history painting. Among his most famous watercolors are those connected with visits to Venice in 1833 and 1840 and to Switzerland, especially the Lake of Lucerne. His later masterpieces, such as *The Fighting "Téméraire,"* 1839 (London, Tate Gallery), and *Slavers Throwing Overboard the Dead and Dying,* 1840 (Boston, Museum of Fine Arts), show his celebrated representation of meteorological effects as embodiments of the forces of nature.

100 SAMUEL PALMER
British, 1805–1881
Sir Guyon with the Palmer Attending, Tempted by Phaedria to Land upon the Enchanted Islands—"Faerie Queene"

Watercolor and bodycolor, with some gum arabic, over black chalk underdrawing, on "London Board"
53.7 x 75.2 cm (21⅛ x 29⁹⁄₁₆ in.)
94.GC.50

The subject is freely adapted from a passage in the Elizabethan poet Edmund Spenser's *Faerie Queene,* first published in 1590. In the boat to the left stand Sir Guyon and the palmer, a character from the poem with whom the artist clearly identified (a "palmer" is a pilgrim who has returned from the Holy Land, in sign of which he carries a palm branch or leaf). Phaedria stands in the boat to the right, gesturing invitingly toward the Enchanted Isle, festive with dancing nymphs and glittering in the evening sun. In Book 2, canto 6, of the poem, Phaedria, however, refuses to take the palmer, much against Sir Guyon's wishes:

> But the *Blacke Palmer* suffred still to stand,
> Ne would for price, or prayers once affoord,
> To ferry that old man over the perlows foord.

This watercolor, conceived as a finished work of art in its own right, was exhibited in 1849 at the Old Watercolour Society. The range of effects that a great watercolorist such as Palmer can achieve are spectacular—from the wonderfully convincing cloud-dappled sky ("Margate mottle," as the artist referred to such effects), to the "protopointillism" (a technique of applying regular small touches of pure color, which are then mixed "optically" by the viewer) of several areas of the foreground, most notably in the foliage on the island, to the right.

INDEX OF ARTISTS
Numerals refer to page numbers